DRIFTLESS

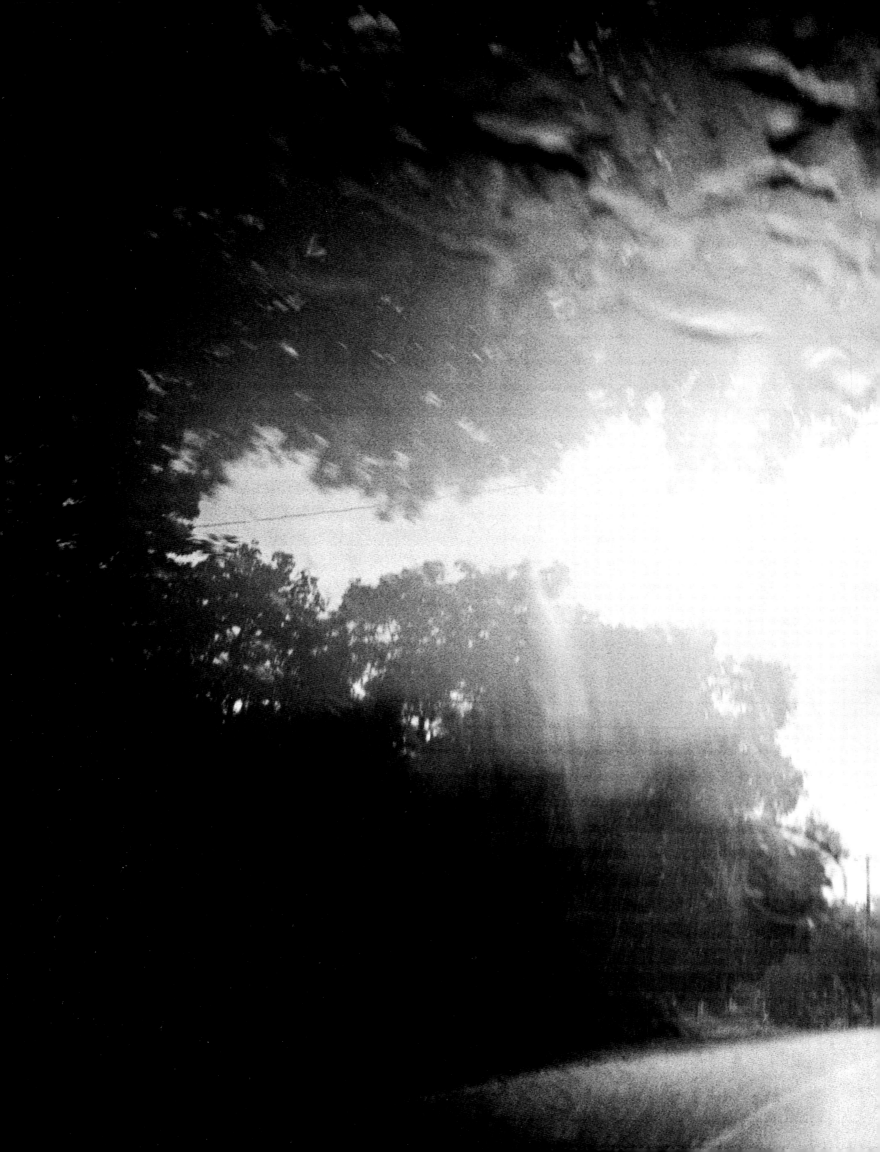

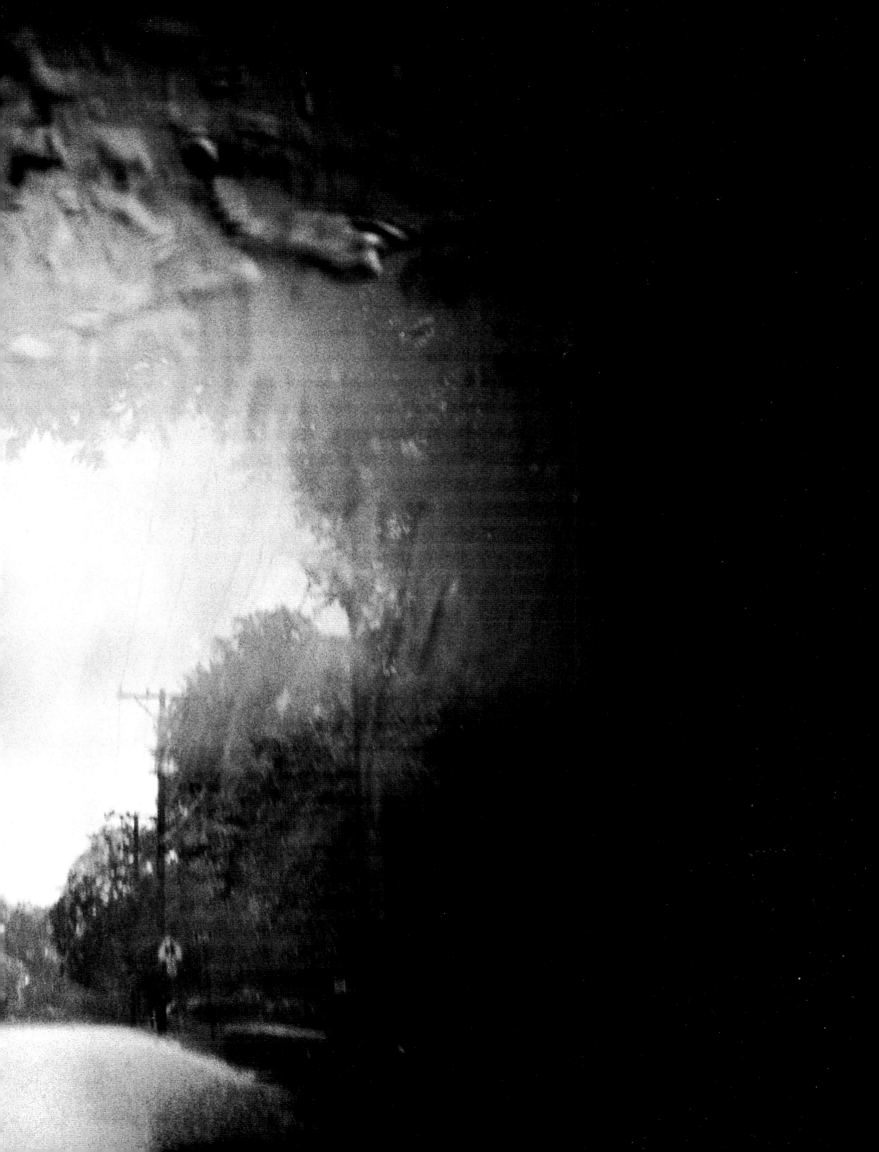

Previous pages: Rainstorm, Iowa City, 2004

IN IOWA

In Iowa once, among the Mennonites
In a slathering blizzard, conveyed all afternoon
Through sleet-gilt pelting hard against the windscreen
And a wiper's strong absolving slumps and flits,

I saw, abandoned in the open gap
Of a field where wilted cornstalks flagged the snow,
A mowing machine. Snow brimmed its iron seat,
Heaped each spoked wheel with a thick white brow,

And took the shine off oil in the black-toothed gears.
Verily I came forth from that wilderness
As one unbaptized who had known darkness
At the third hour and the veil in tatters.

In Iowa once. In the slush and rush and hiss
Not of parted but as of rising waters.

—*Seamus Heaney*

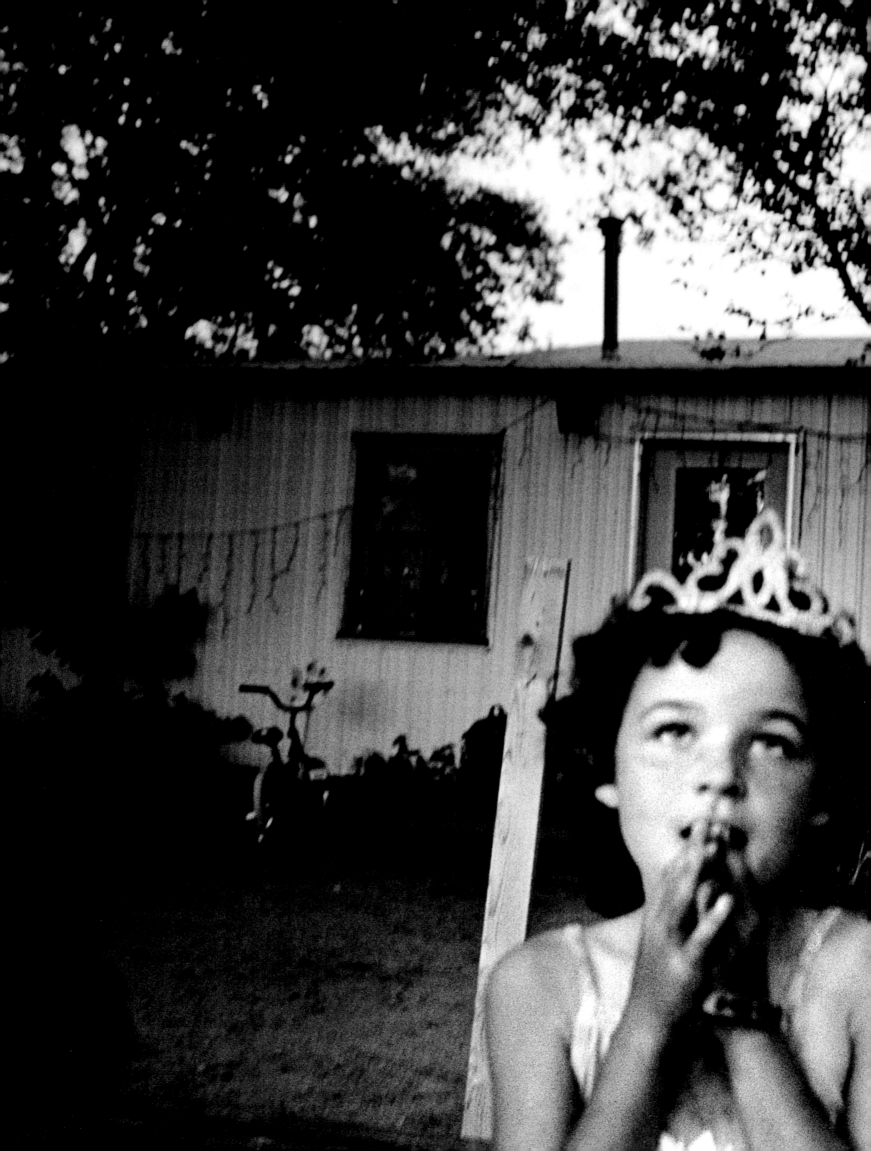

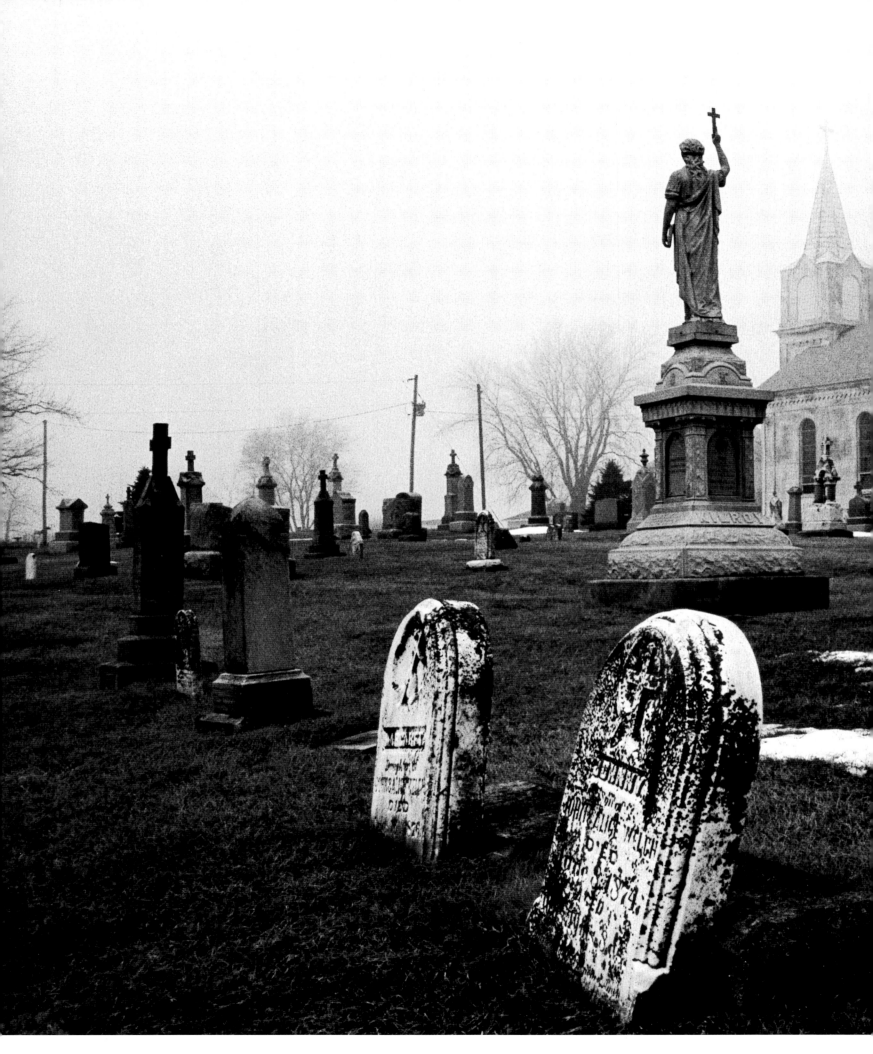

Previous pages: A young girl dreams of becoming a summer festival queen like her older sister, Conesville, 2003

Above: Cemetery, St. Michael's Church, Holbrook, 2003

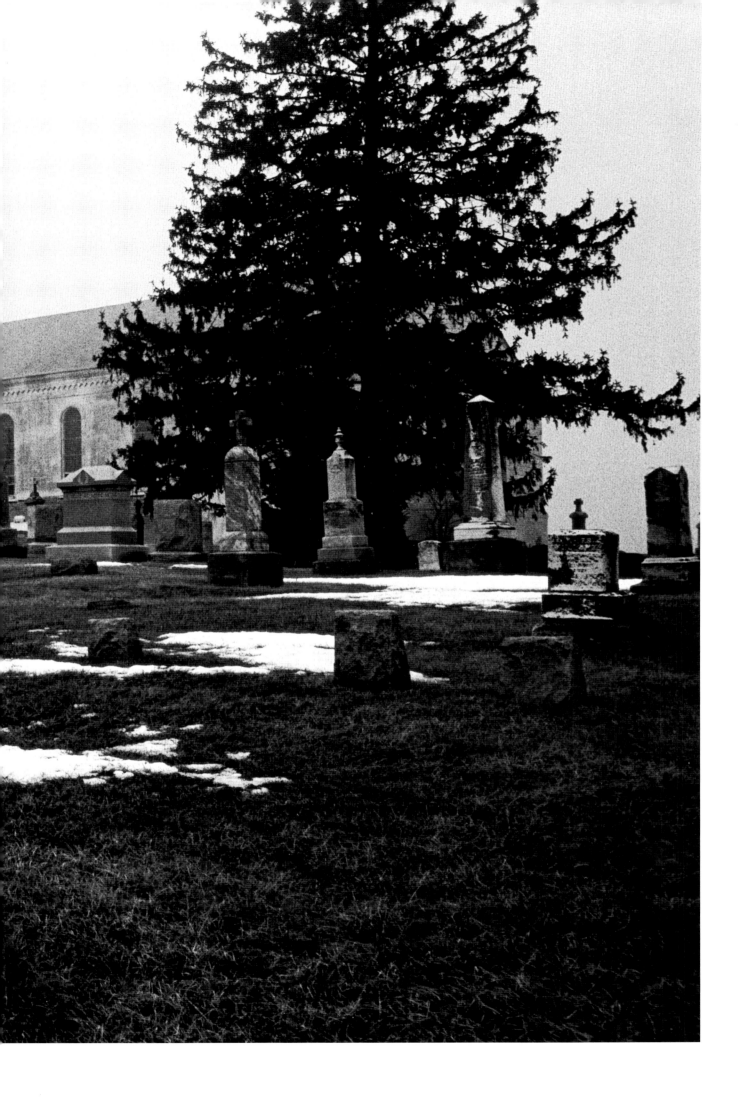

Winner of the

Center for Documentary Studies/

Honickman First Book Prize in Photography

DRIFTLESS

PHOTOGRAPHS FROM IOWA

Bill & Julie,
Seems like yesterday
that I was swimming
in your backyard.

Best,
Danny Wilcox Frazier

DANNY WILCOX FRAZIER

ΓH A FOREWORD BY ROBERT FRANK

A CDS Book
Published by Duke University Press
in association with the Center for Documentary Studies
Durham, North Carolina

For Lydia, Forrest, and Tatum Cree
and for my father-in-law, George Eiting

FOREWORD
ROBERT FRANK

Driftless is Frazier's document about rural Iowa. His home.
It makes me think that this "BOY" has never gone away
from home. Years of working, walking, photographing,
carefully making notes, names, places.

He is able to complete a personal "ALBUM" of eighty
photographs. Inhabitants: Farmers, Migrant Workers, their families,
Hunters, Churches, Trailers, Storms, Open Fields, Sunday Night. . . .

Passionate photographs without sentimentality. Frazier is able
to push background into foreground (strong winds?). Yes—his work
reaches out: let me tell your story, it is important.

Like an older brother, he shows us facts with passion and the
dream of a young girl in front of a trailer becoming a
Summer Festival Queen in America.

Frazier's work will survive—his book will be the
foundation for more to come. . . .

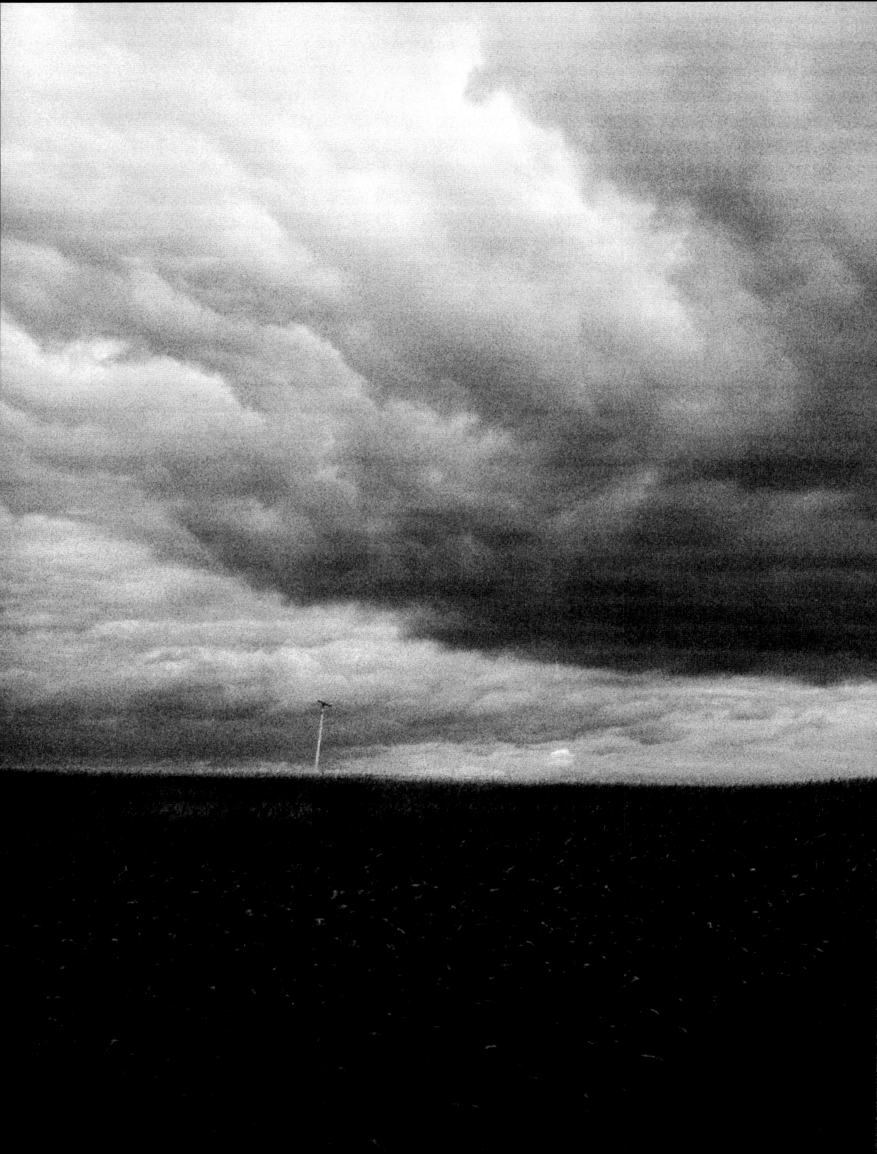

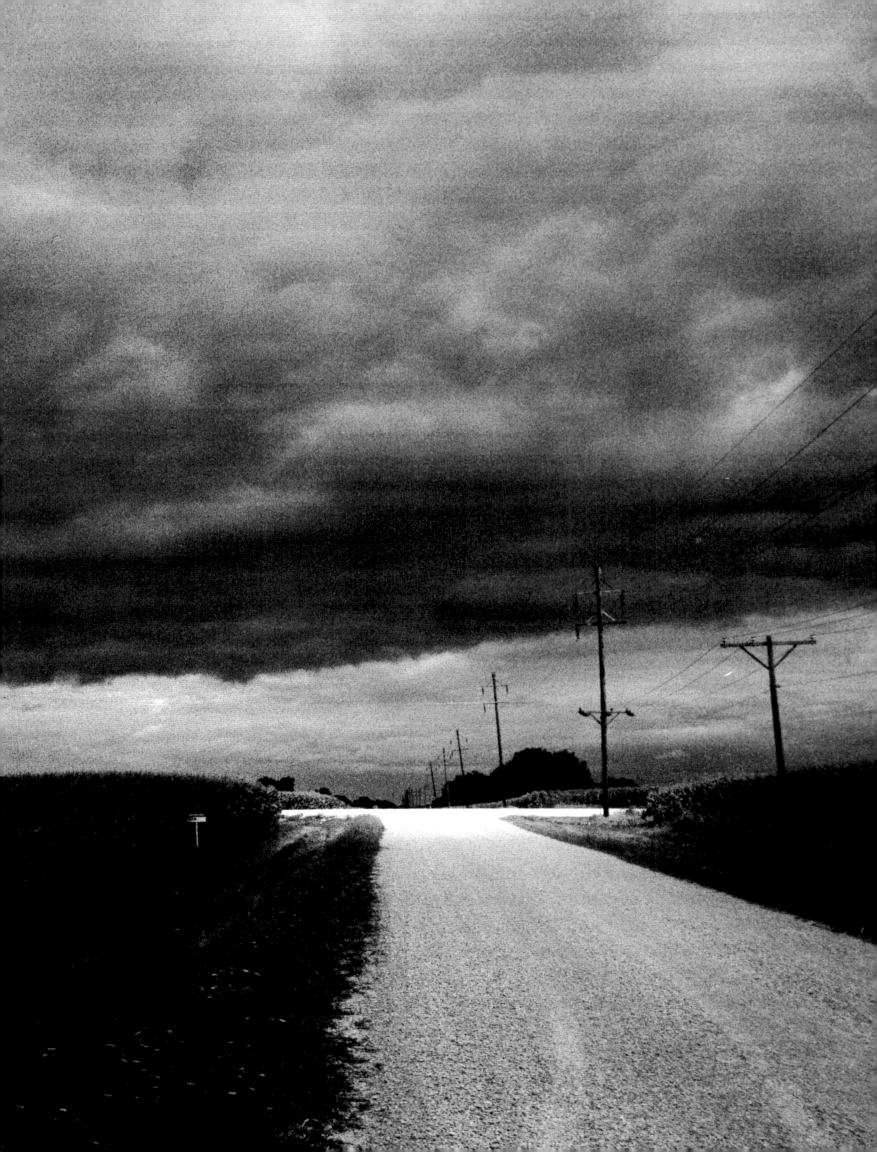

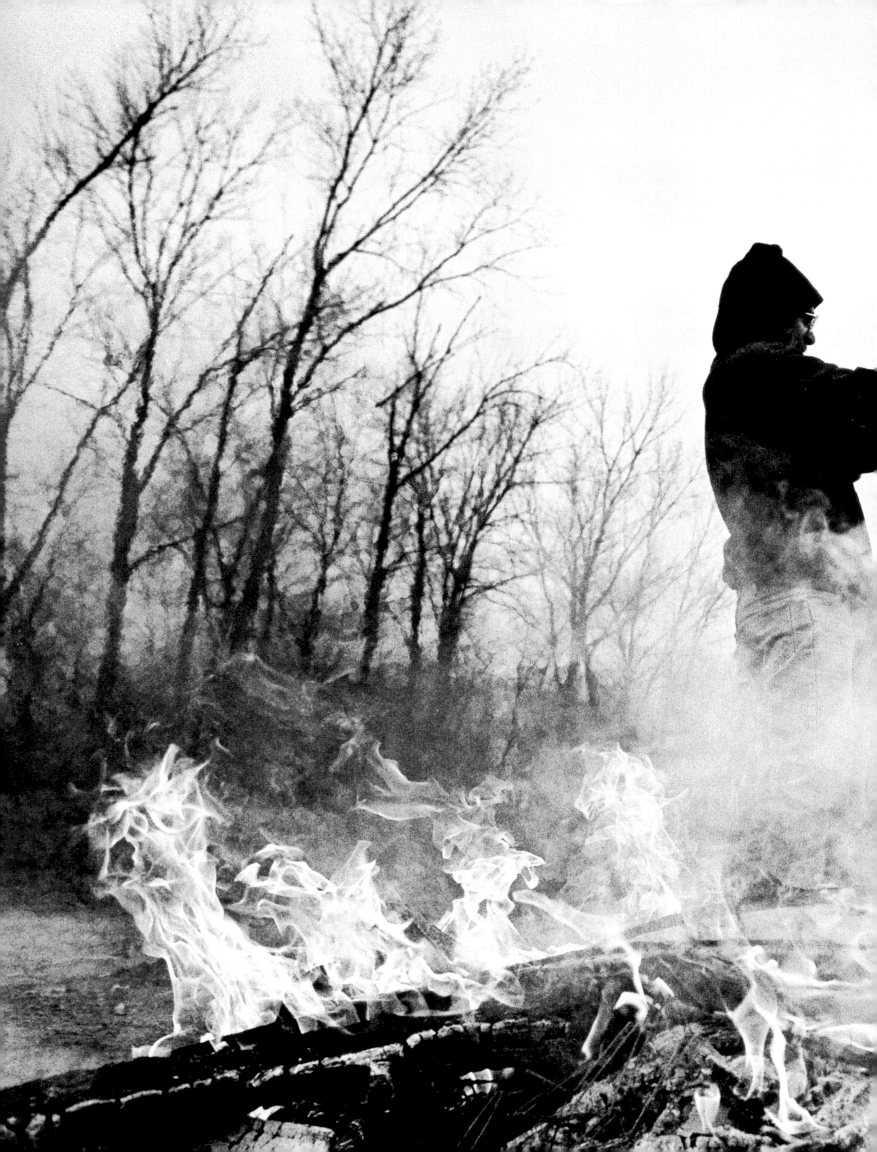

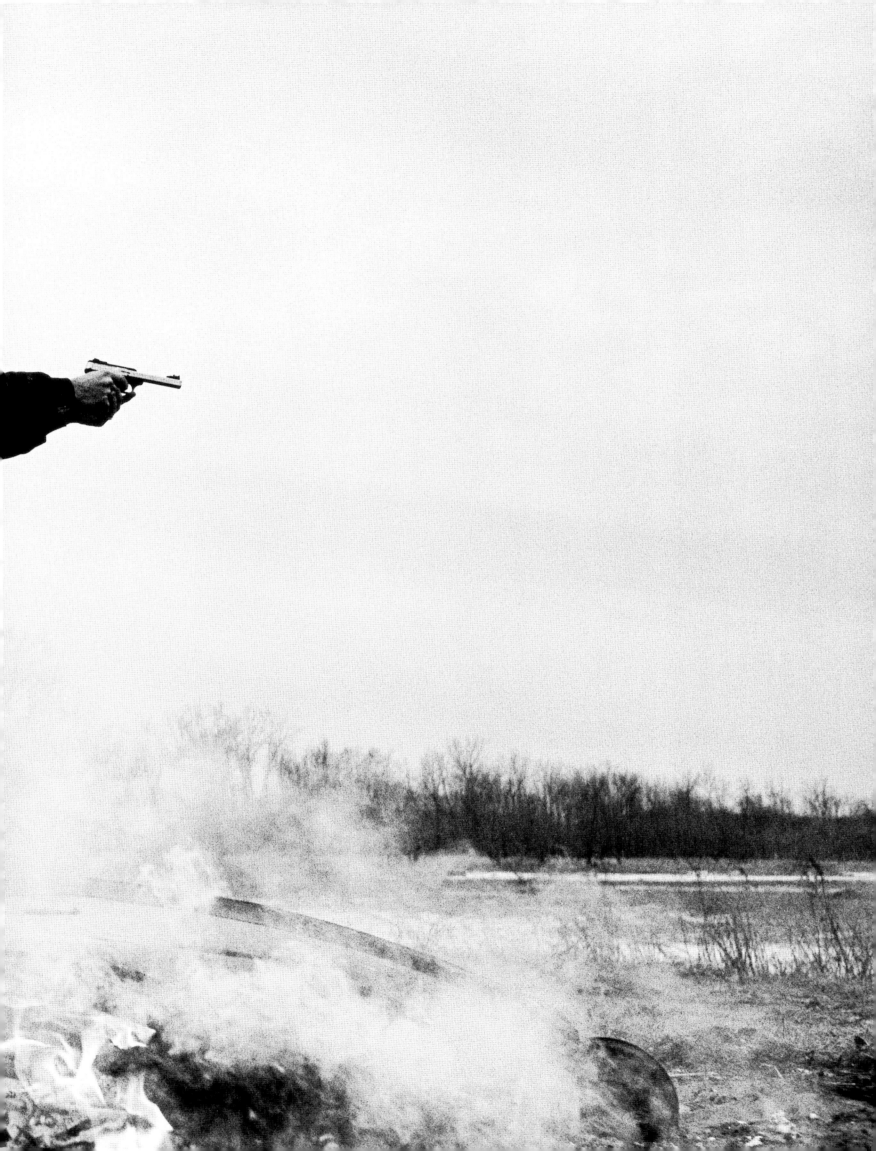

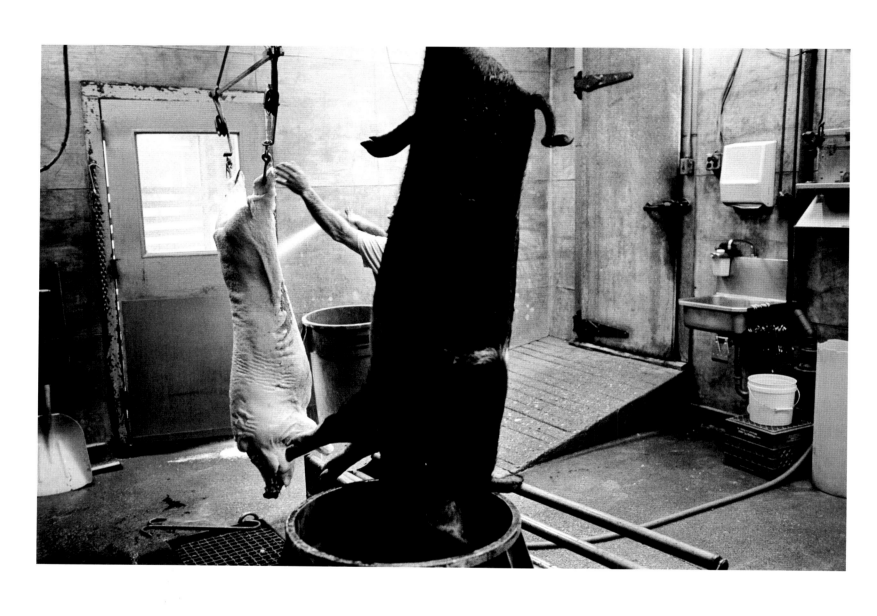

Previous pages: A storm appears over a cornfield near Le Claire, 2004; Shooting bottles along the Iowa River, Johnson County, 2003

Above: Slaughterhouse, Solon, 2003

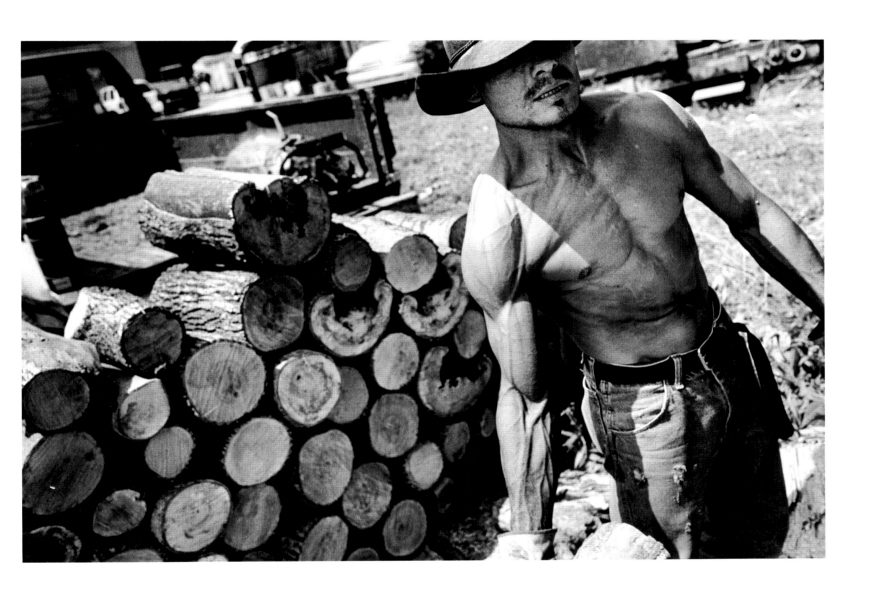

Bull rider and farmhand Rusty Caudle, North Liberty, 2003

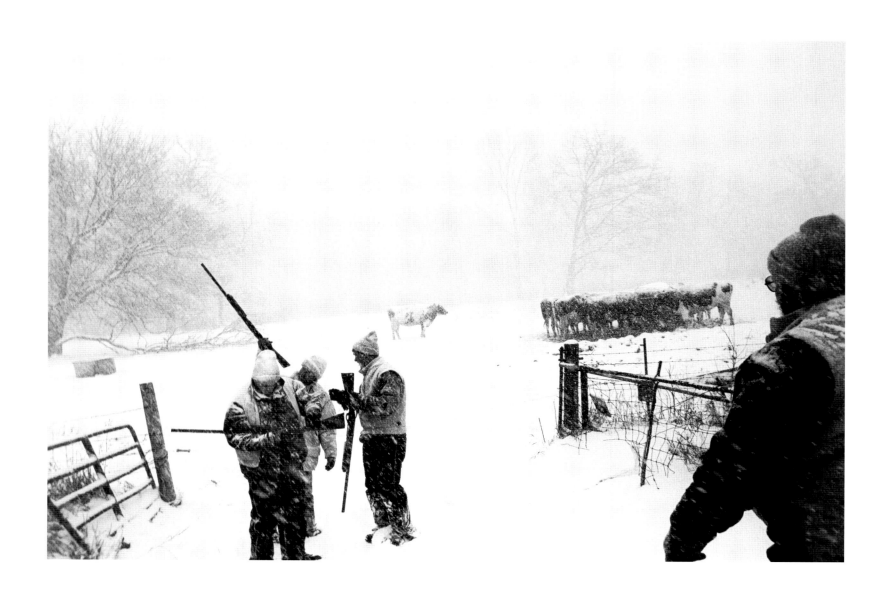

Guns are checked as snowfall limits visibility, opening day of deer season, near Kalona, 2005

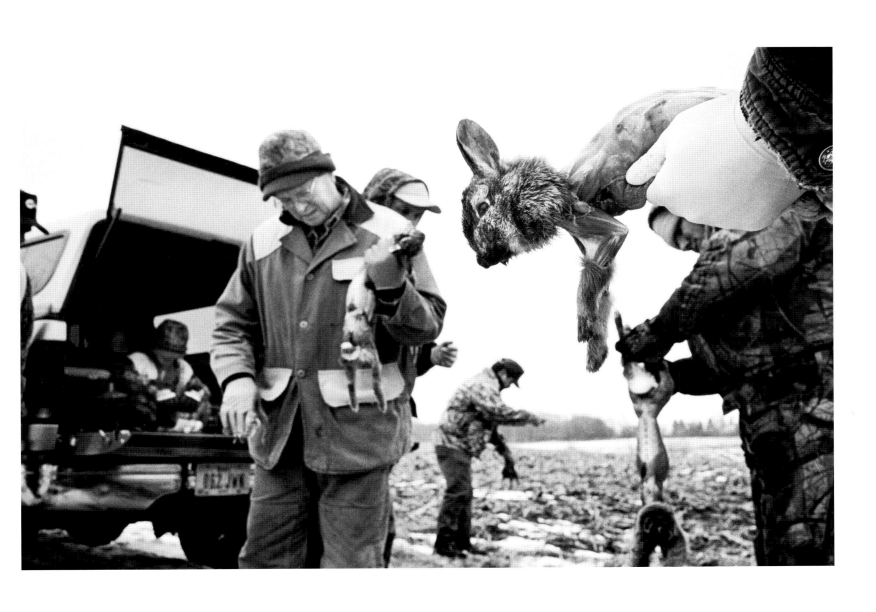

Rabbit hunters skin the day's kill, Washington County, 2003

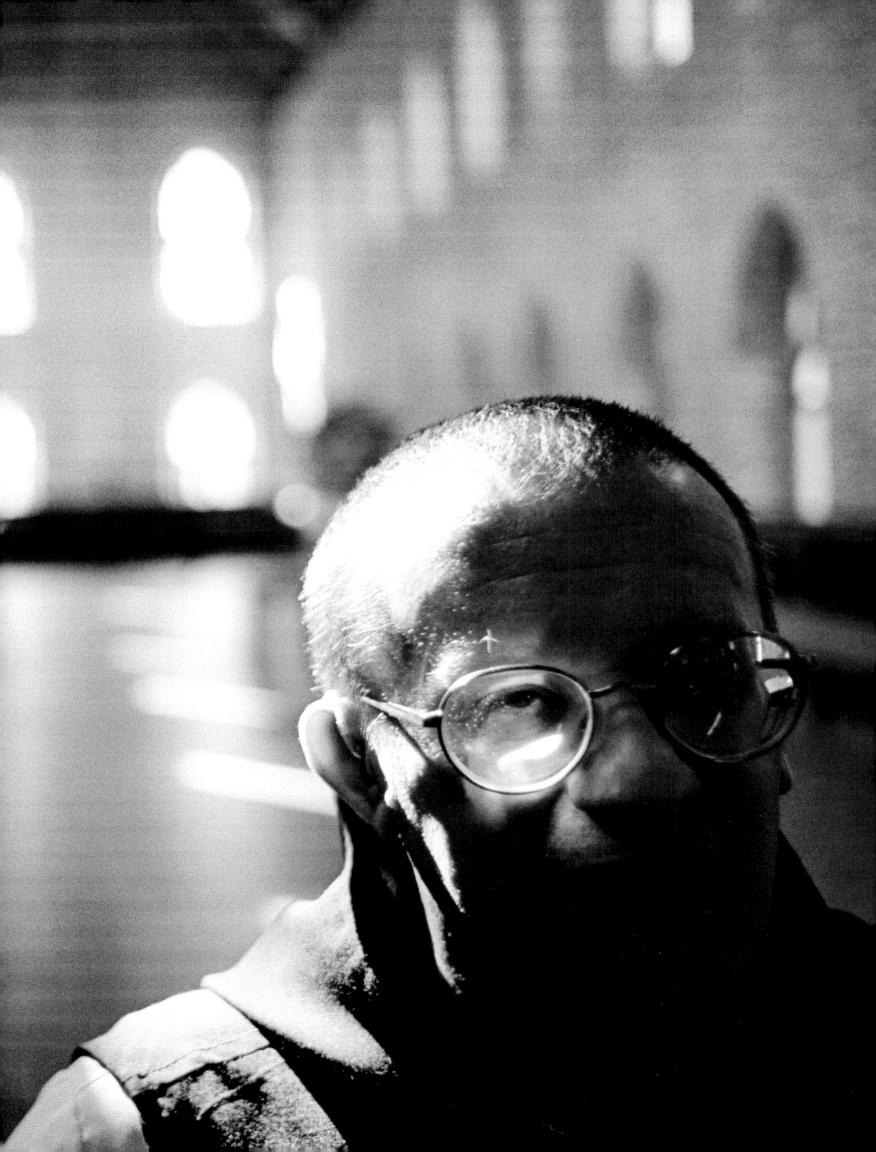

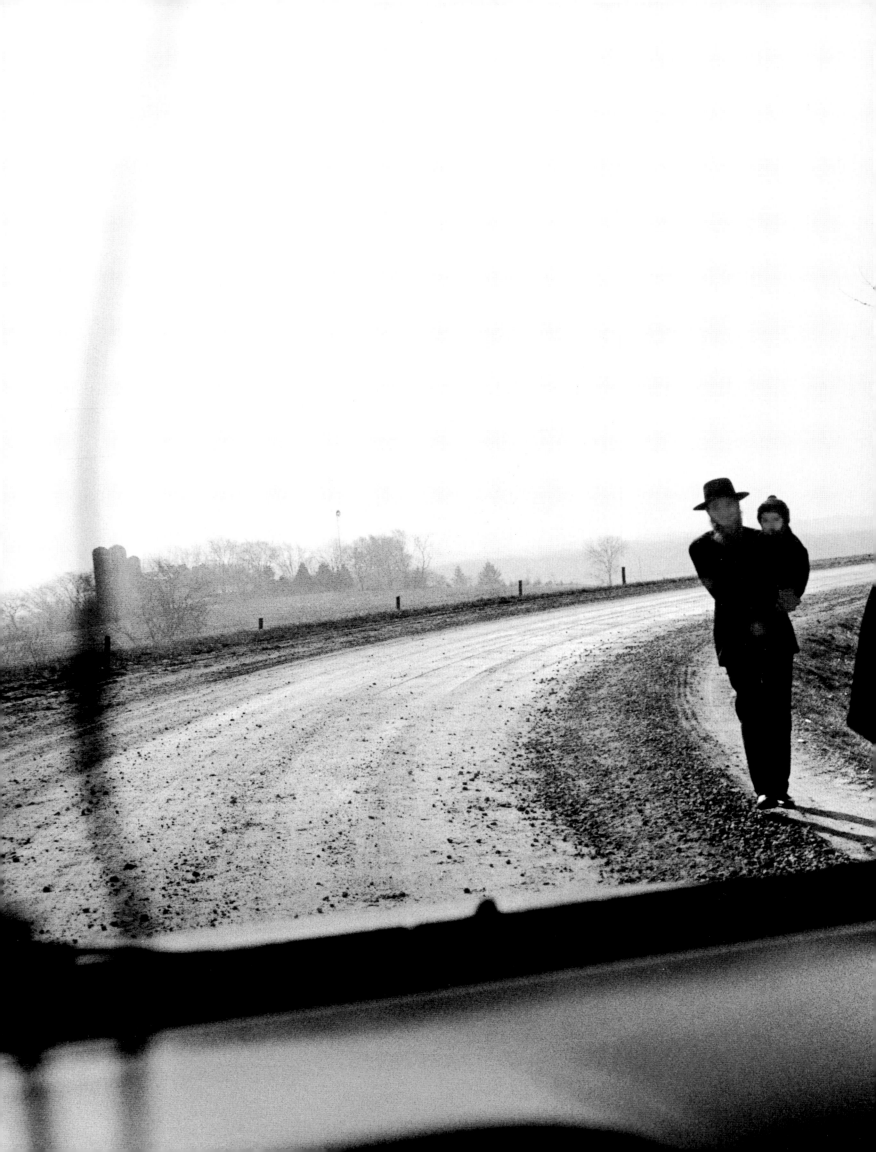

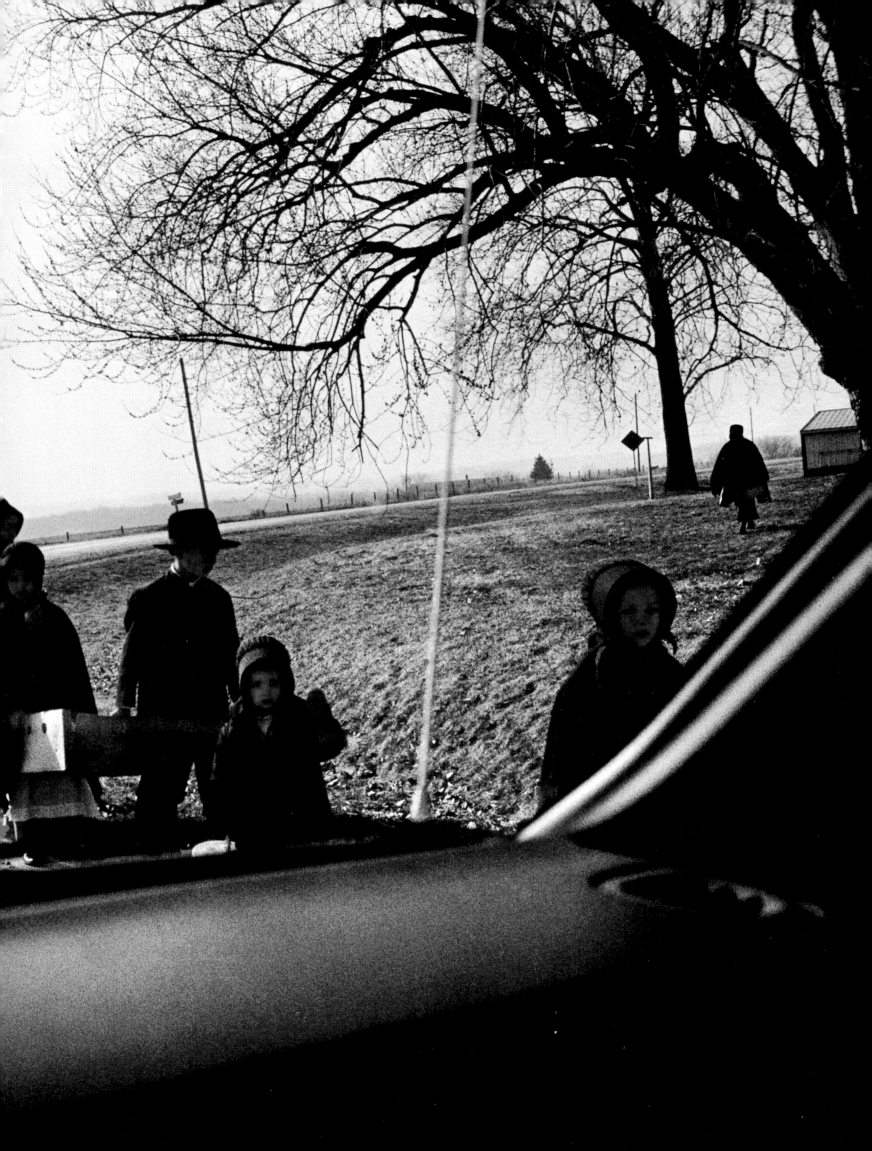

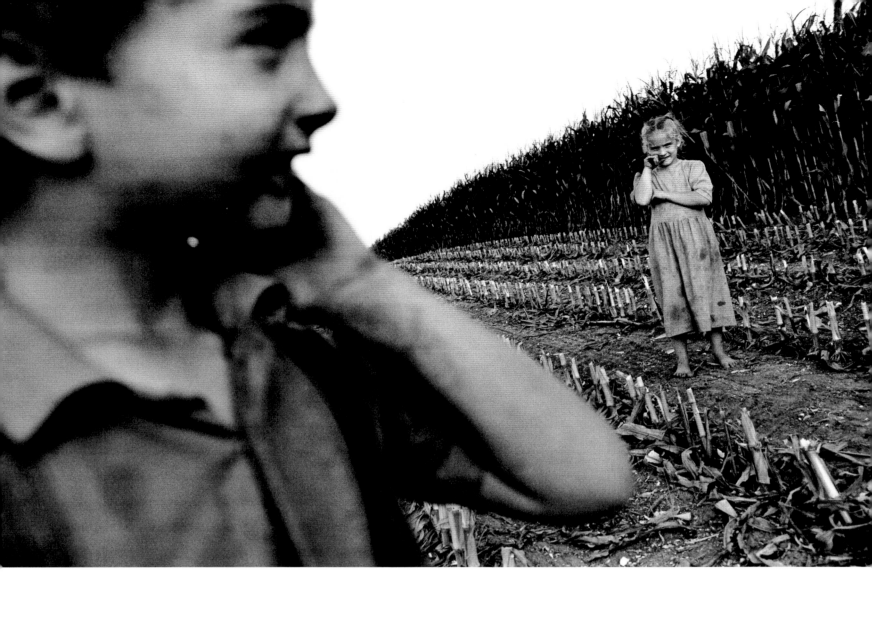

Previous pages: Cistercian monk, New Melleray Abbey, Peosta, 2003; An Old Order Amish family walks to church on Easter Sunday, Washington County, 2005; *Above:* Junior and Rachel Miller play while corn is harvested on the family farm, Kalona, 2005

Opposite: Allen Miller and his seven-year-old sister, Rachel, who are New Order Amish, chop corn, Kalona, 2005

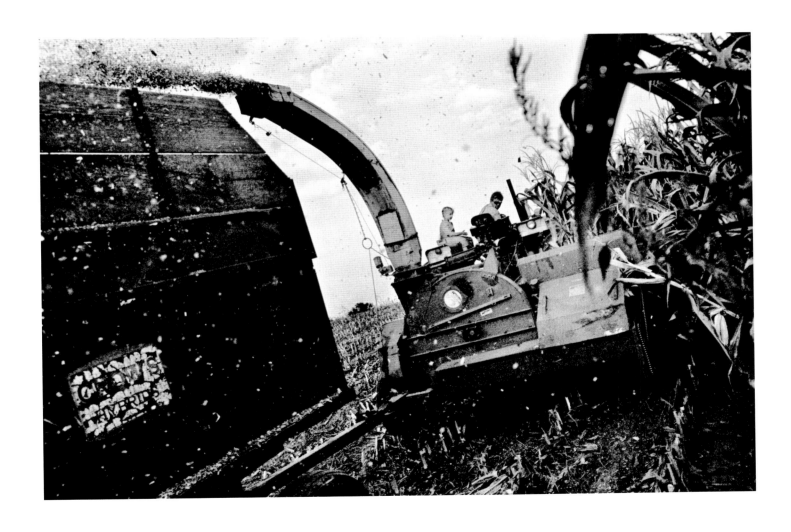

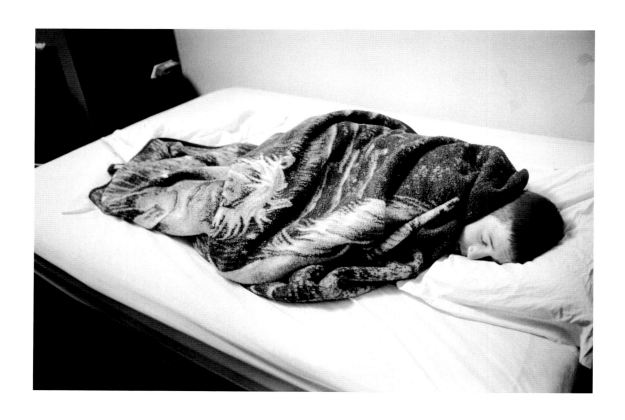

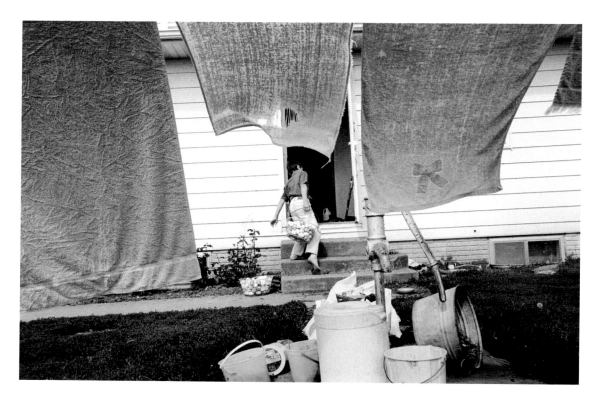

Top: Kevin Stutzman, who normally rises at five a.m. to milk cows, sleeps in, Kalona, 2003

Bottom: Gabriel Stutzman, the youngest of nine children raised by his Beachy Amish parents on the family's farm, Kalona, 2003

Opposite: Gabriel Stutzman and his brother, Karlin, collect firewood for the wood-burning furnace that heats their home, Kalona, 2003

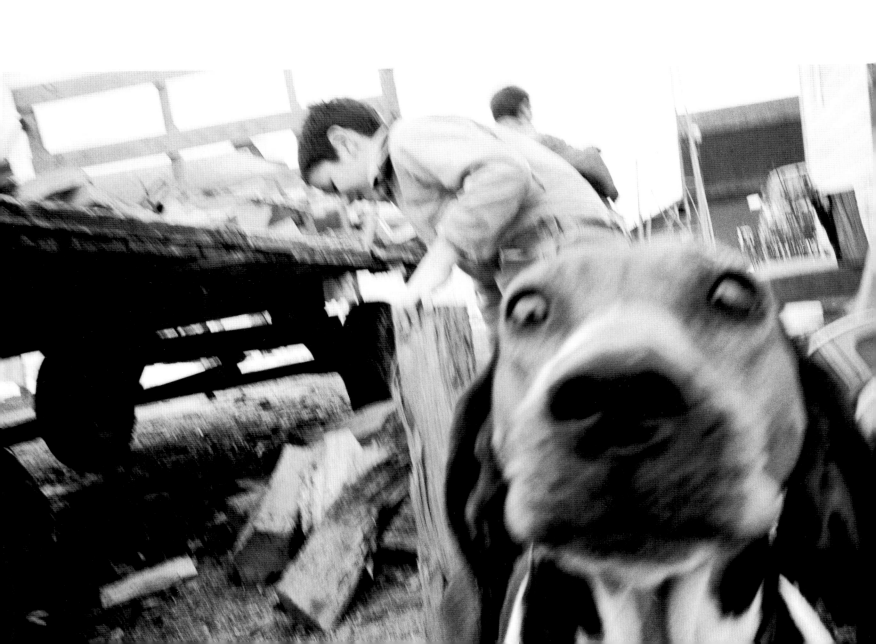

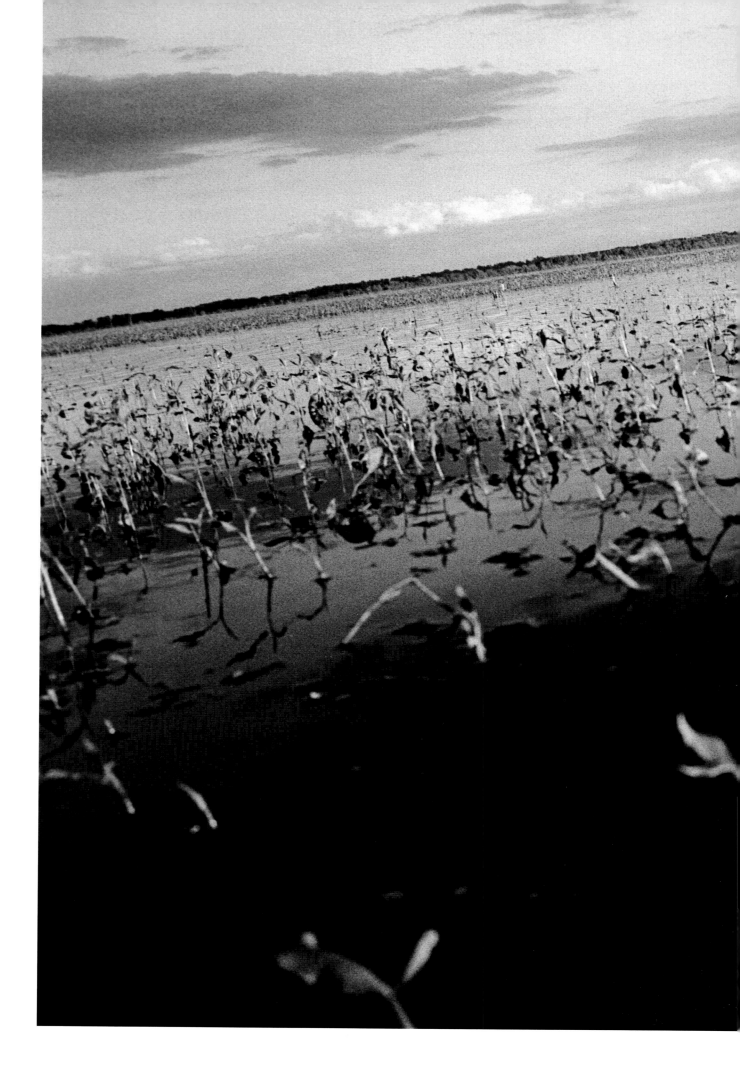

Bowfishing during spawning season, Iowa River, 2005

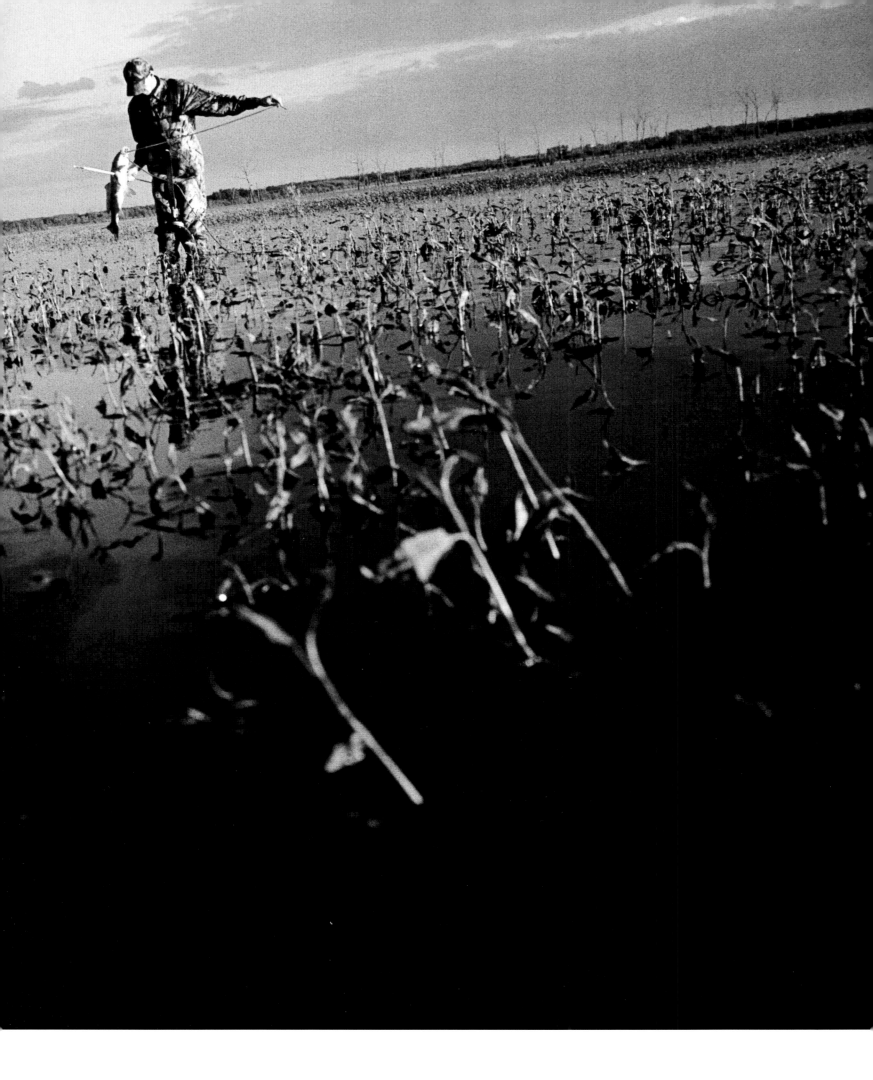

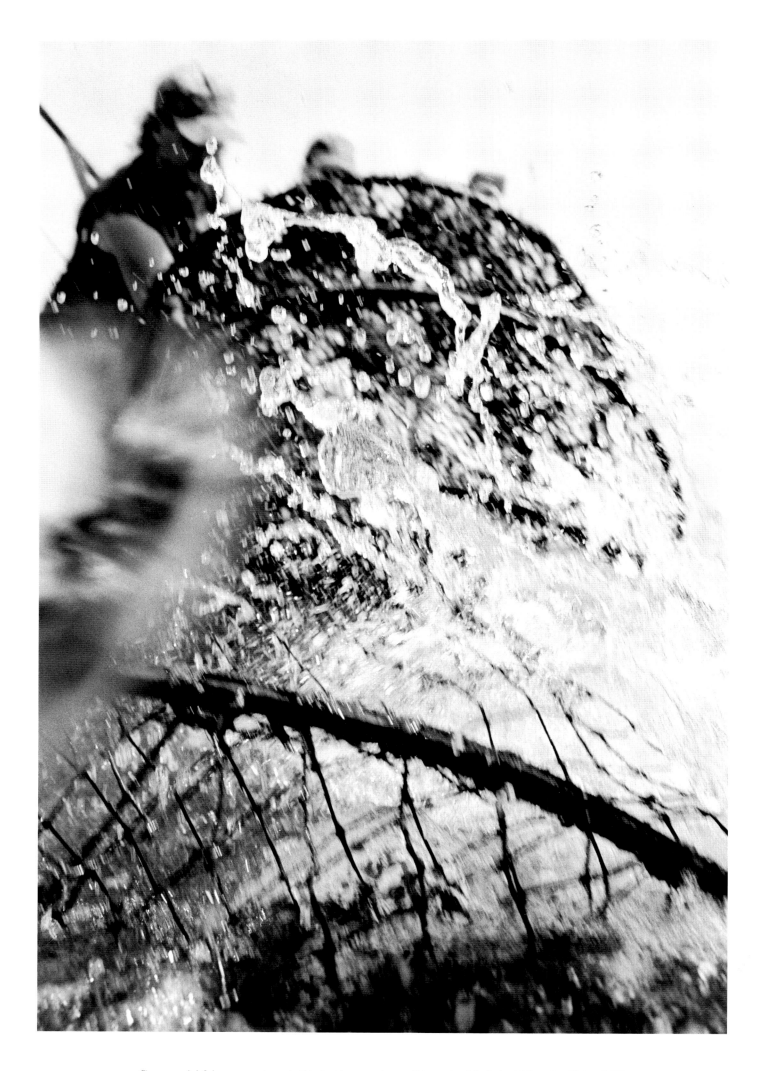

Commercial fishermen raise nets filled with spawning catfish on the Mississippi River, Le Claire, 2005

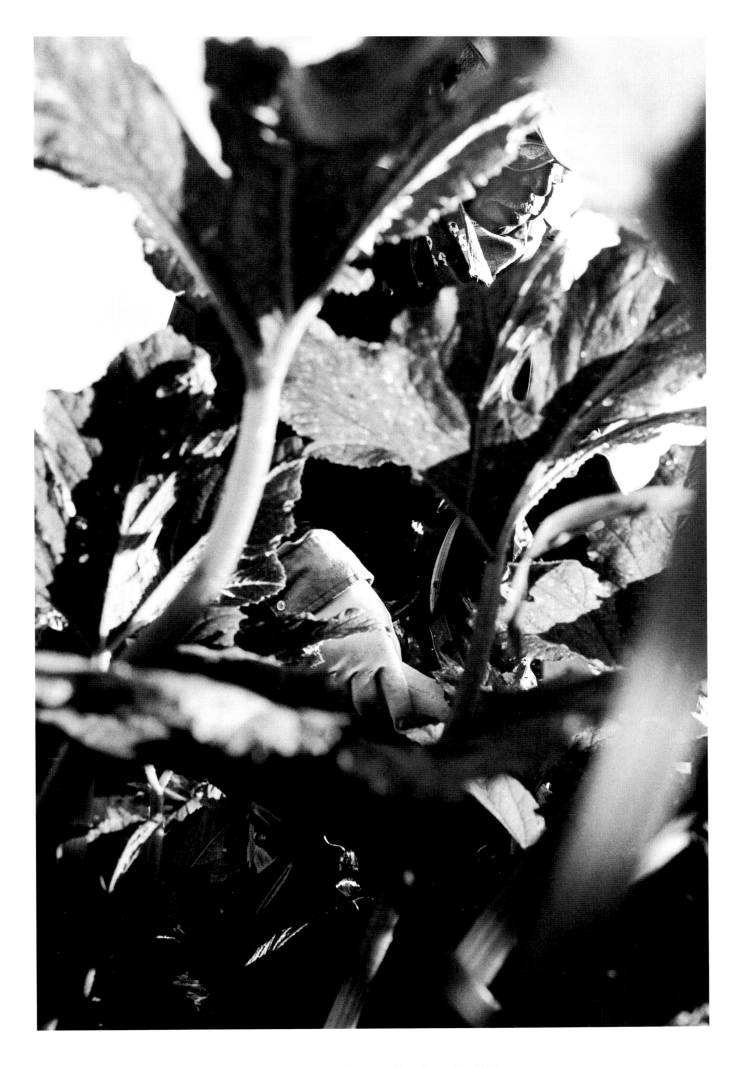

Migrant worker picking vegetables, Conesville, 2003

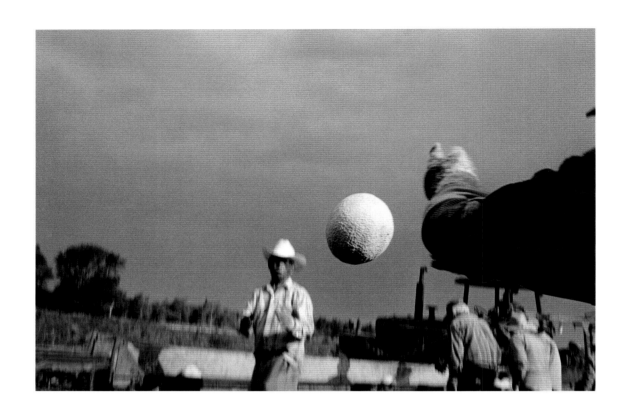

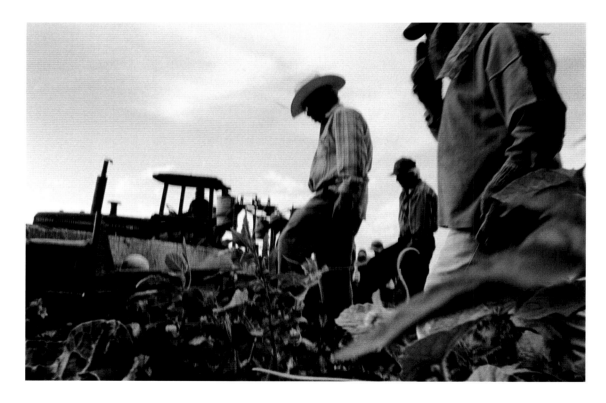

Top and bottom: Migrant workers in the field, Conesville, 2006

Opposite: Latino residents share drinks on a summer evening, Conesville, 2003

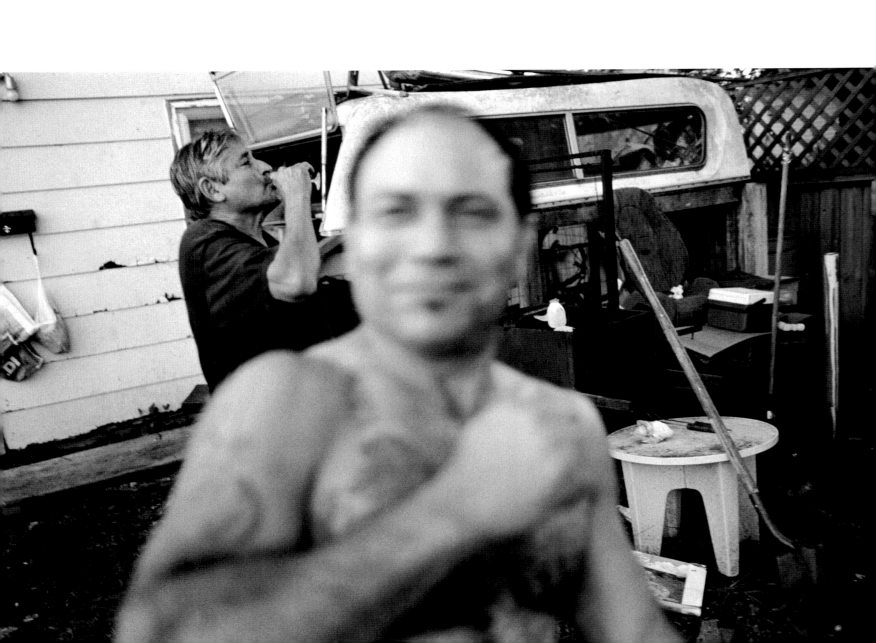

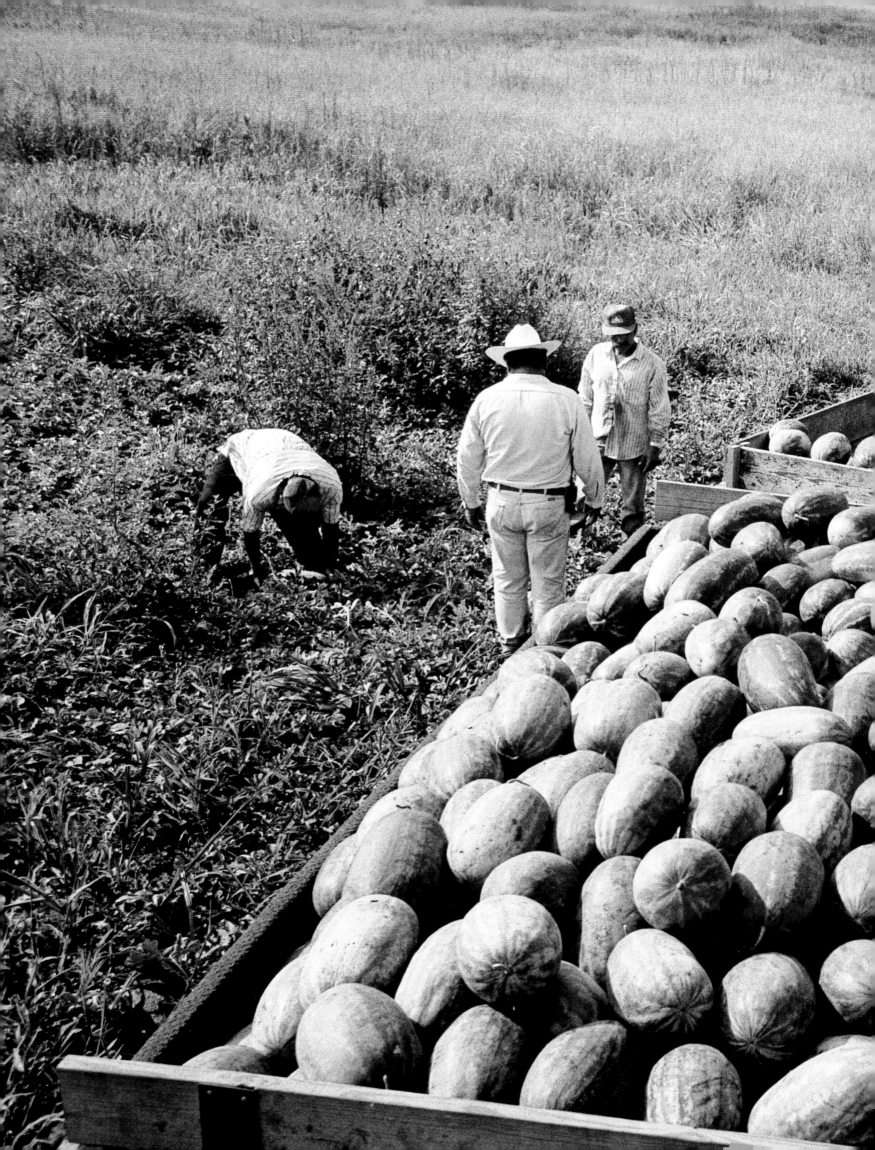

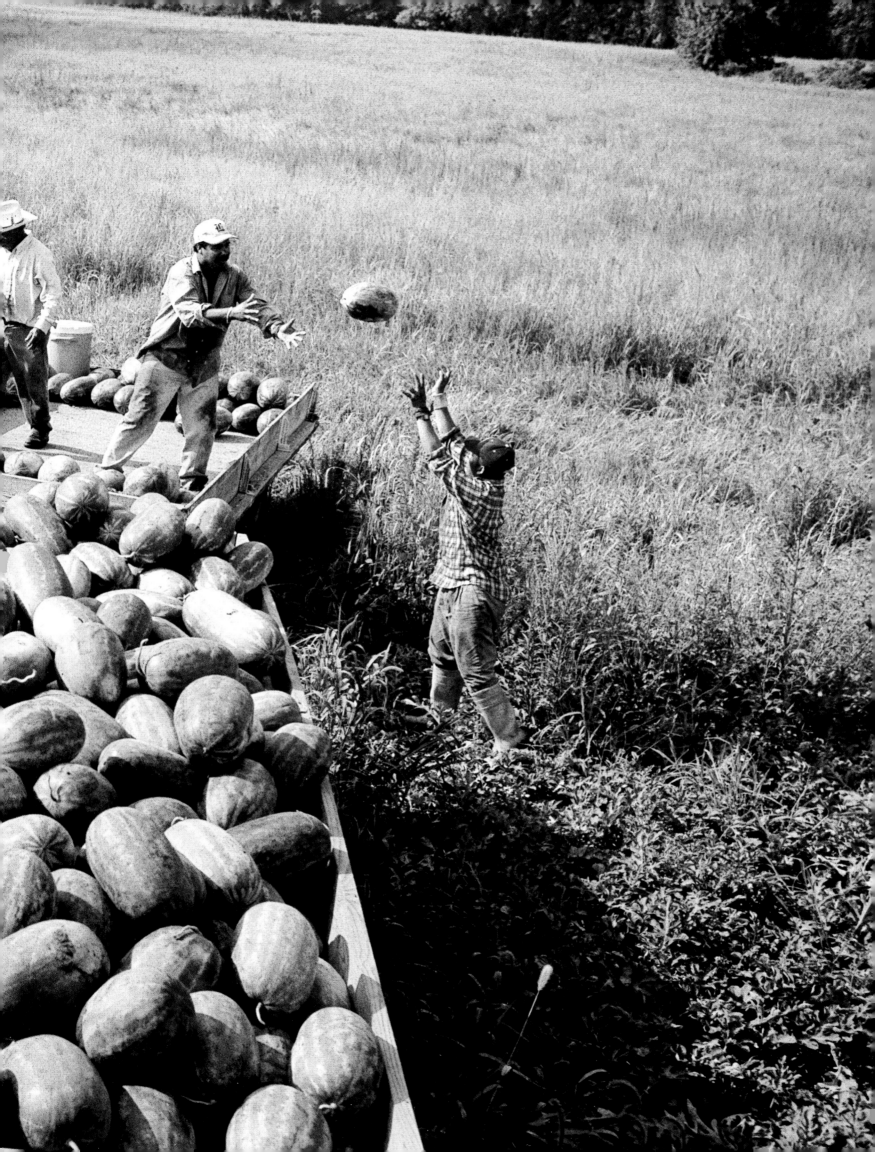

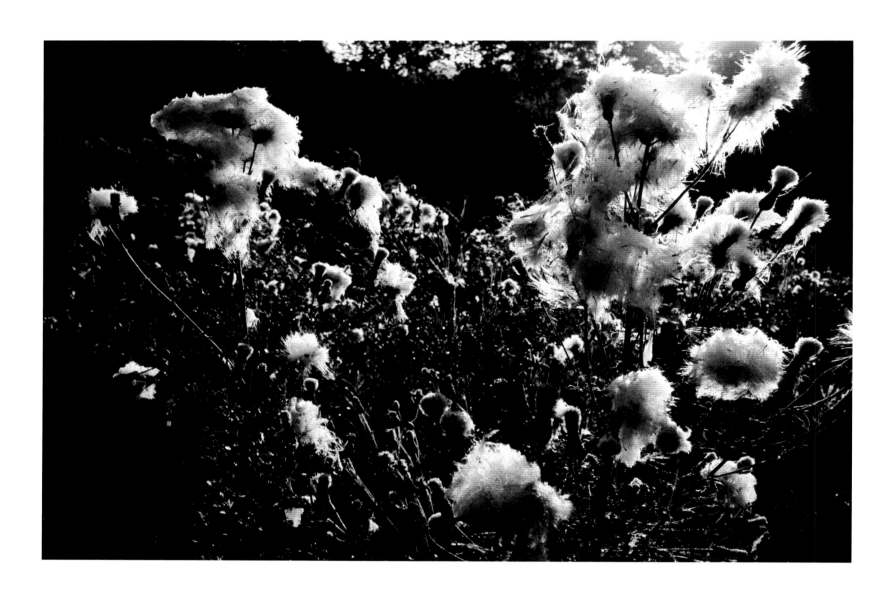

Previous pages: Migrant workers endure long hours bent over while harvesting watermelon, Conesville, 2003

Above: Sunrise, Yellow River State Forest, 2003

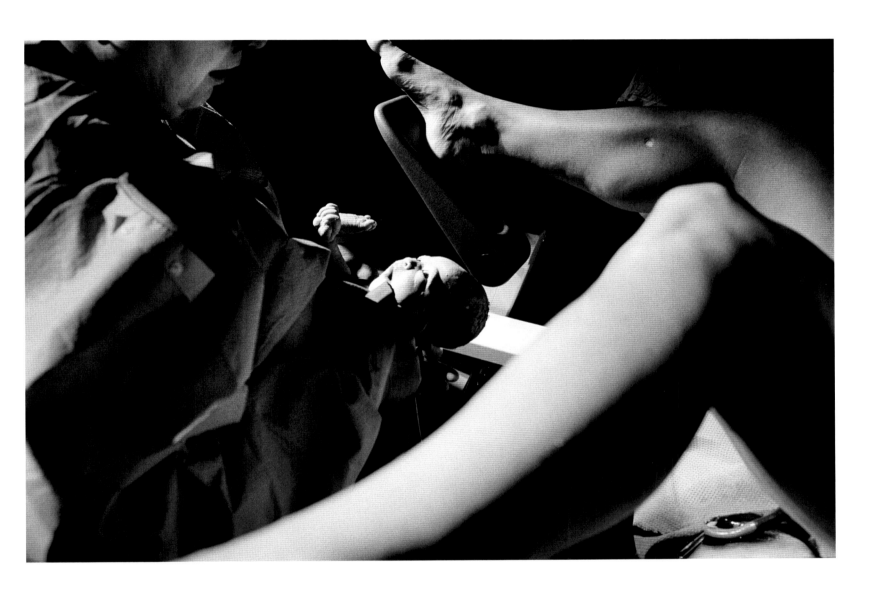

Lydia and Tatum Cree, Iowa City, 2004

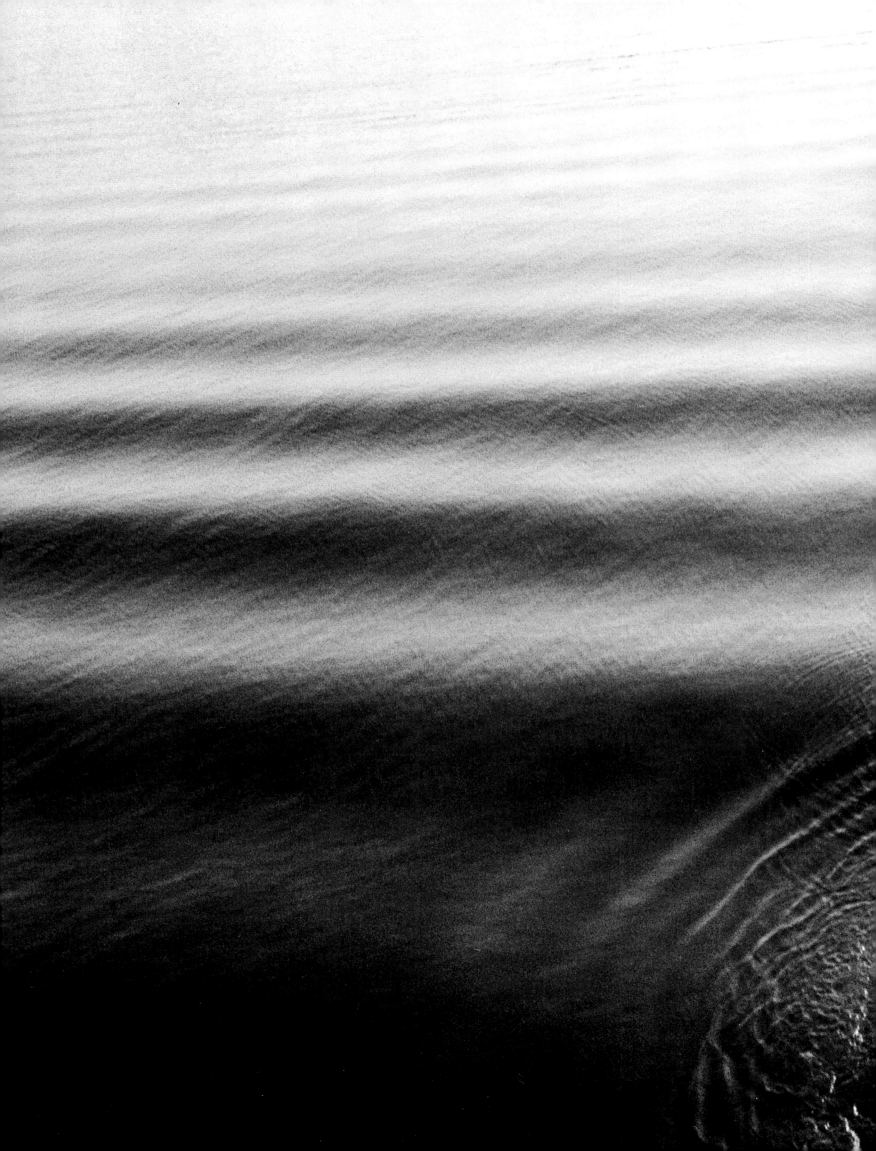

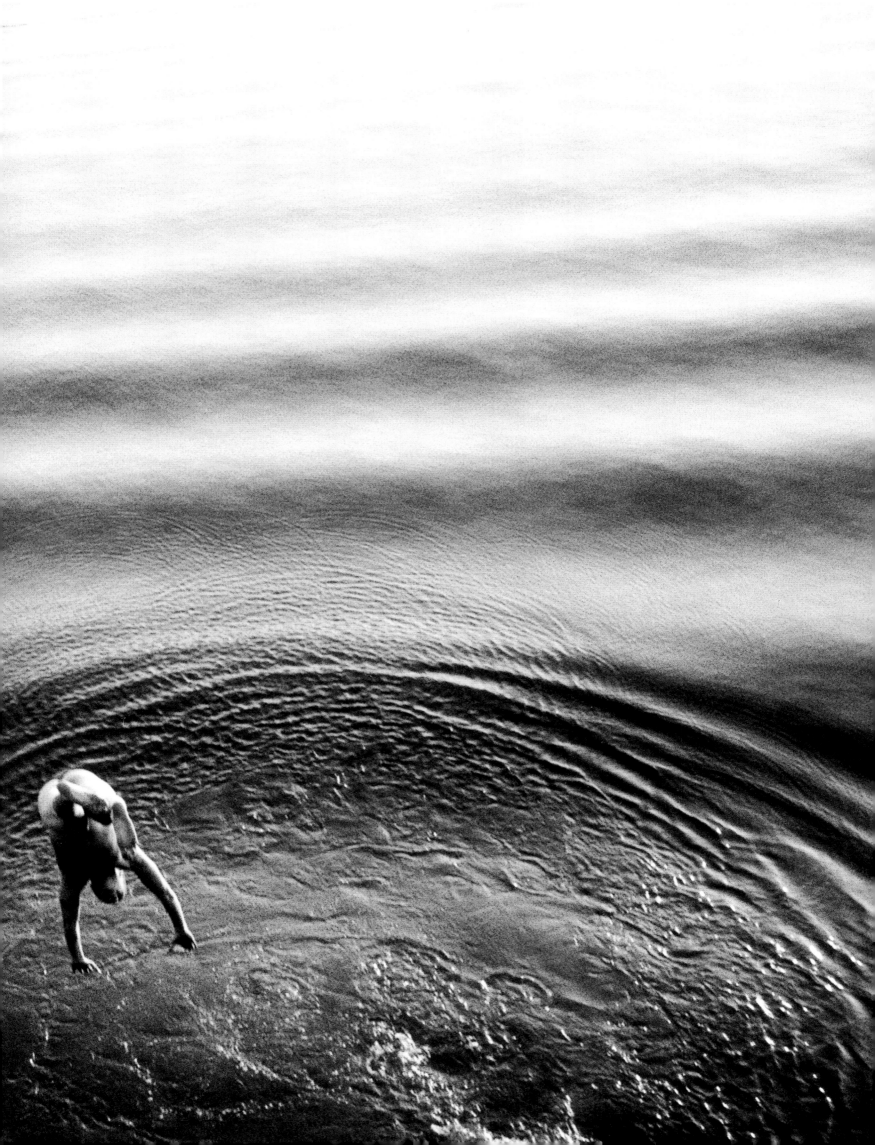

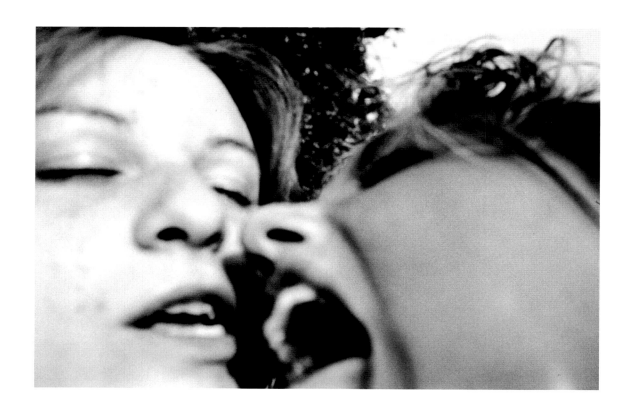

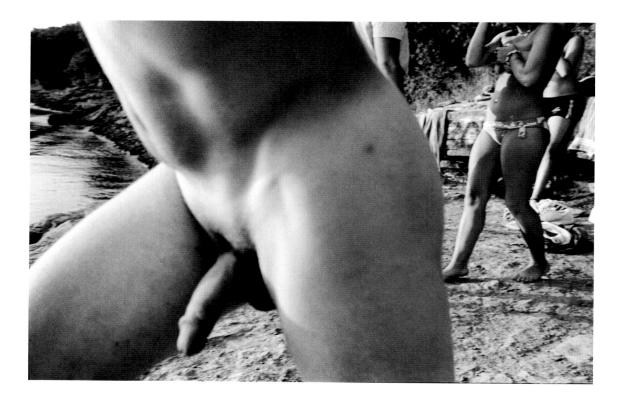

Previous pages, top, and bottom: At Jumping Rock, a notorious party spot along the Iowa River, North Liberty, 2004

Opposite: At Jumping Rock, 2003

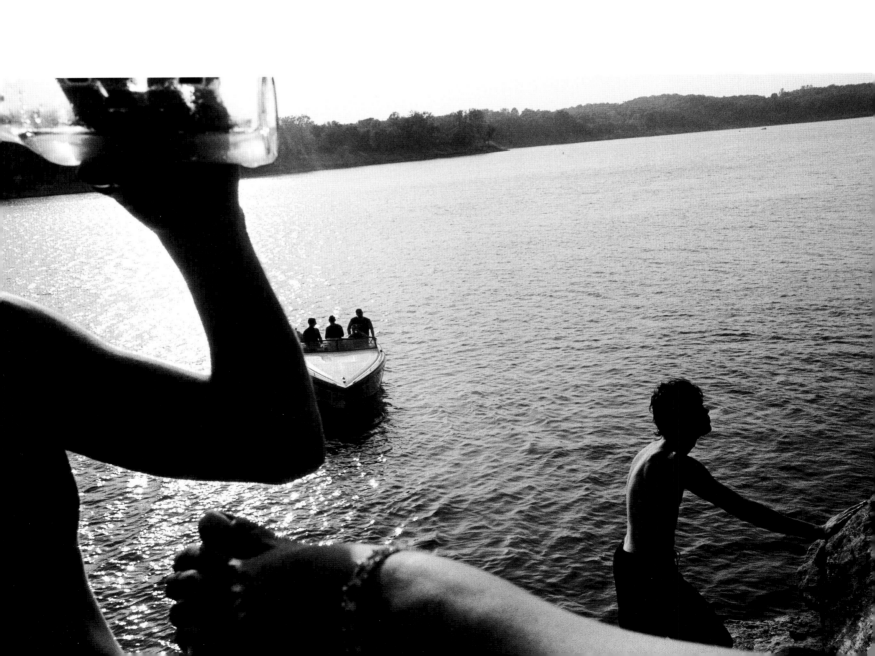

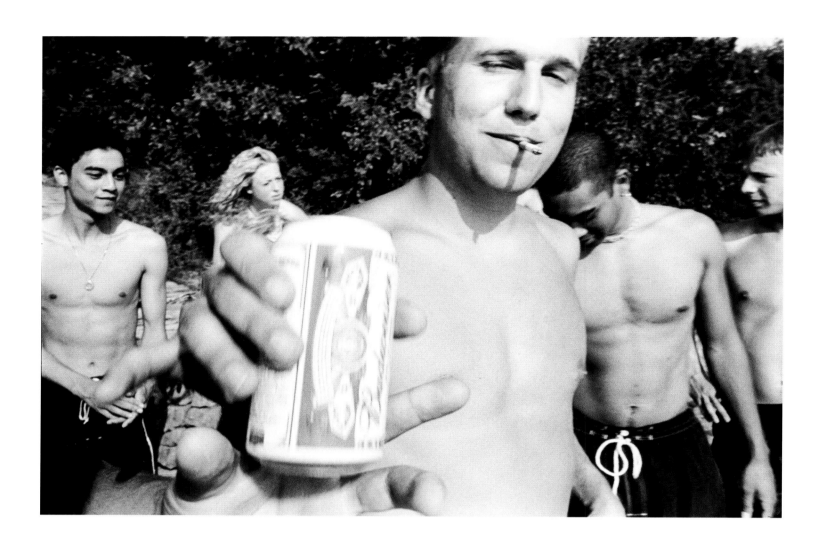

Above: At Jumping Rock, North Liberty, 2003; *Opposite:* Cliff diving at Jumping Rock, North Liberty, 2004

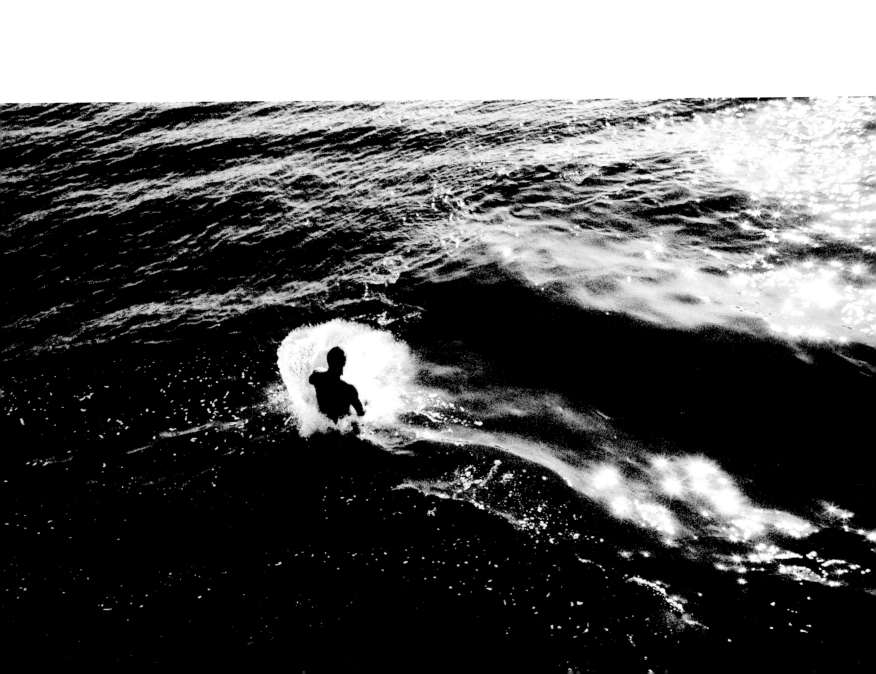

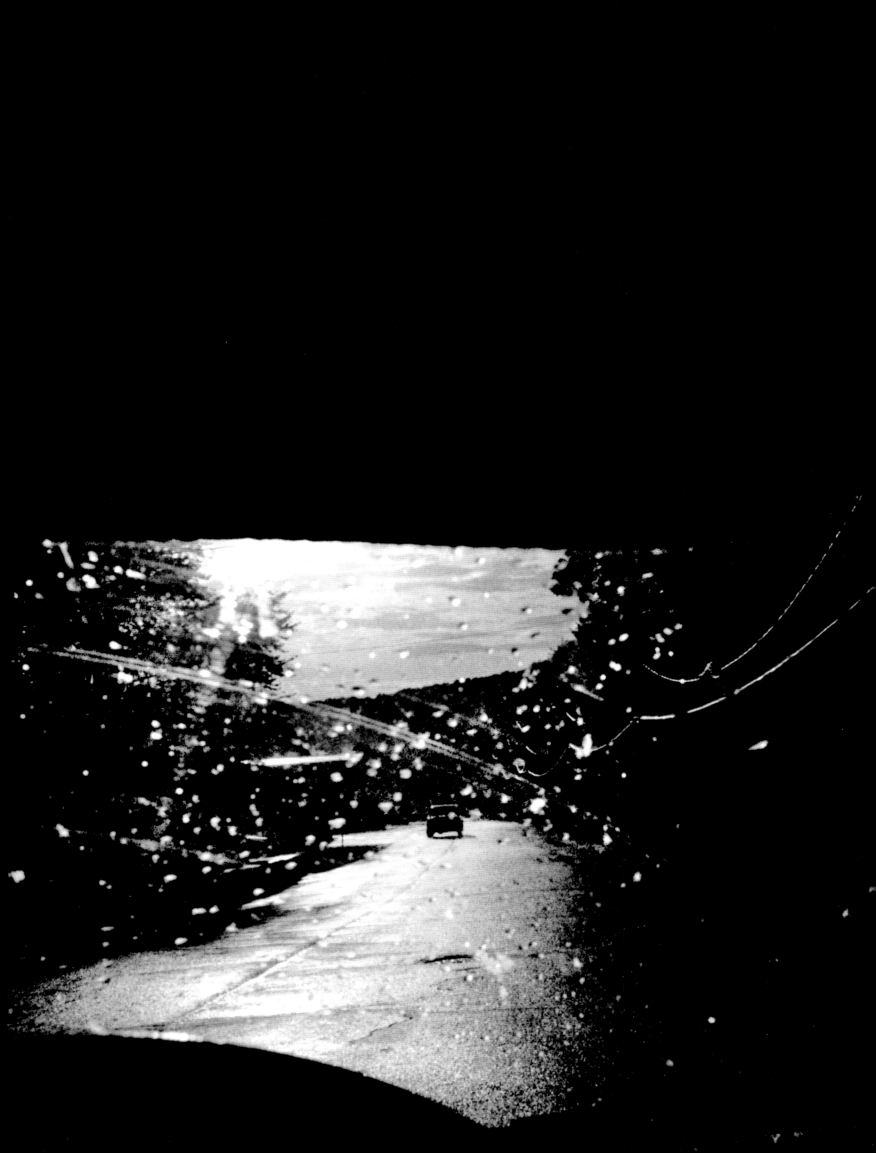

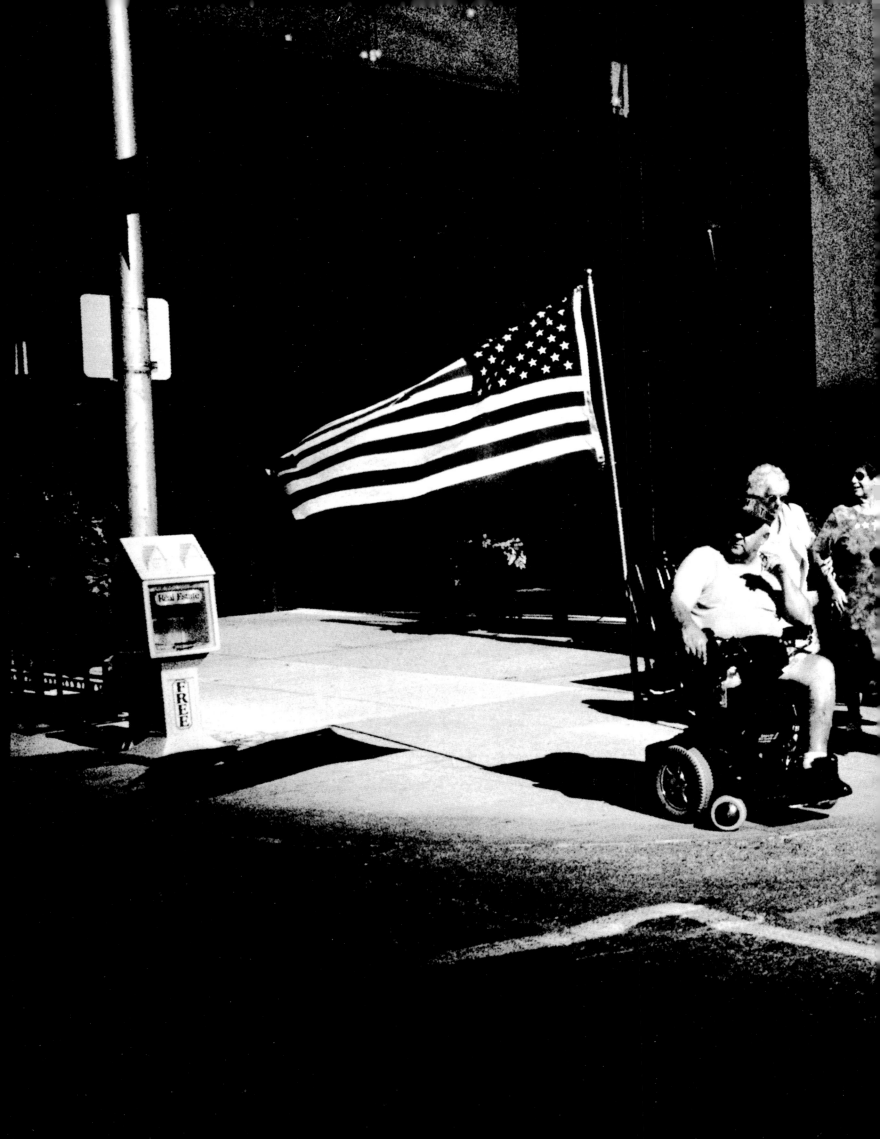

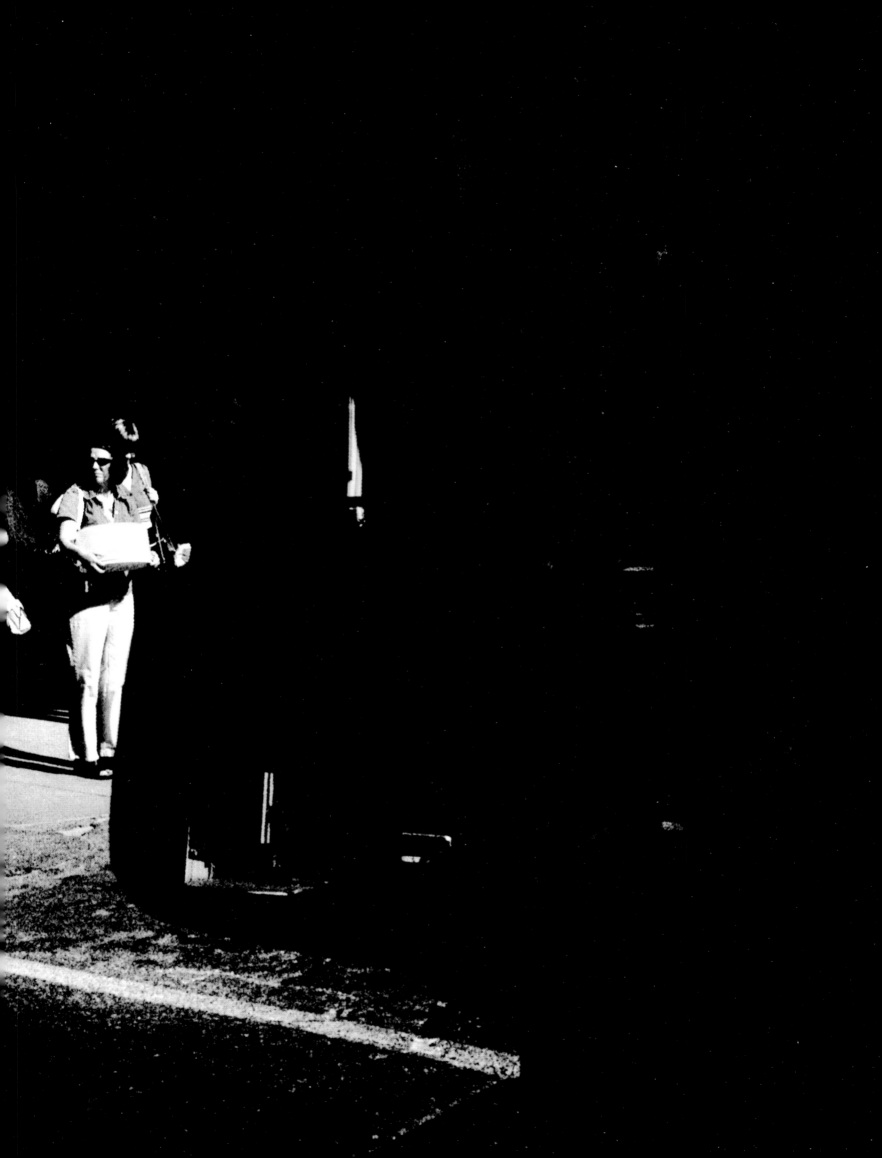

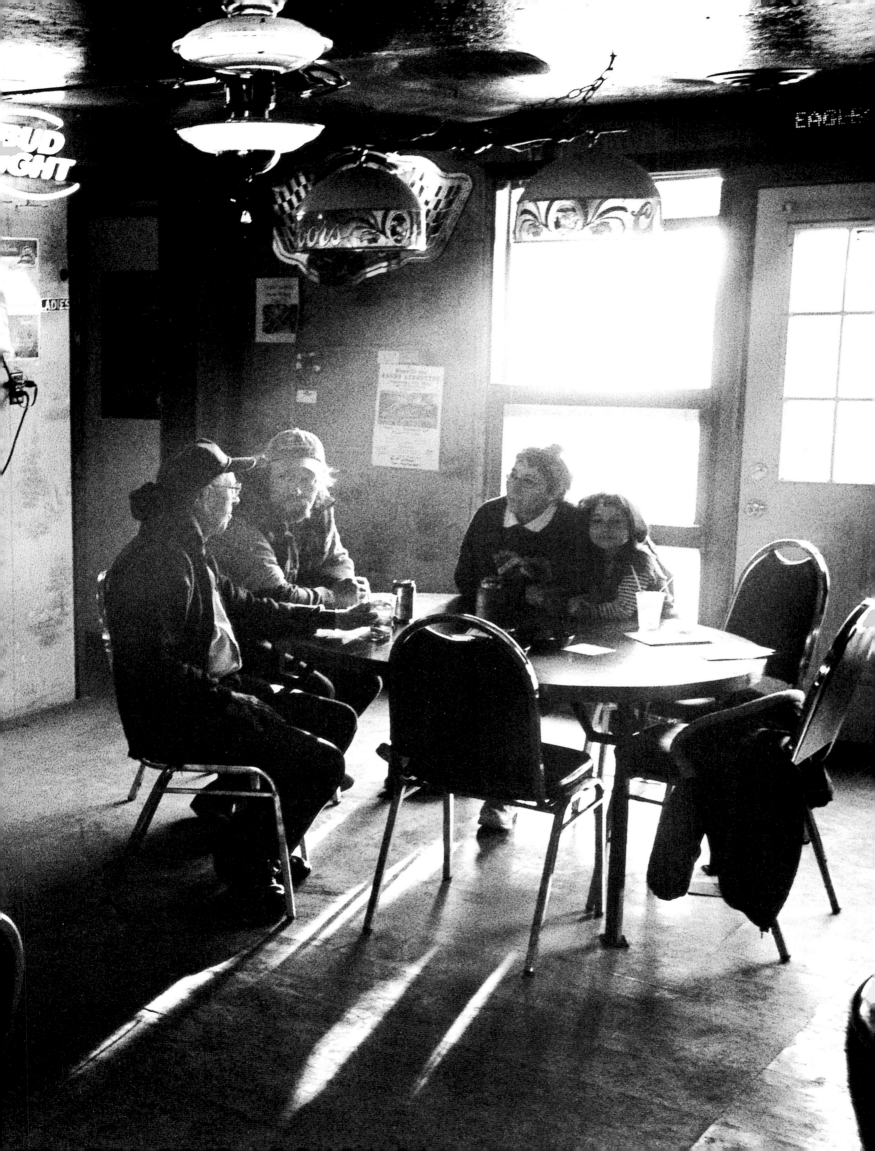

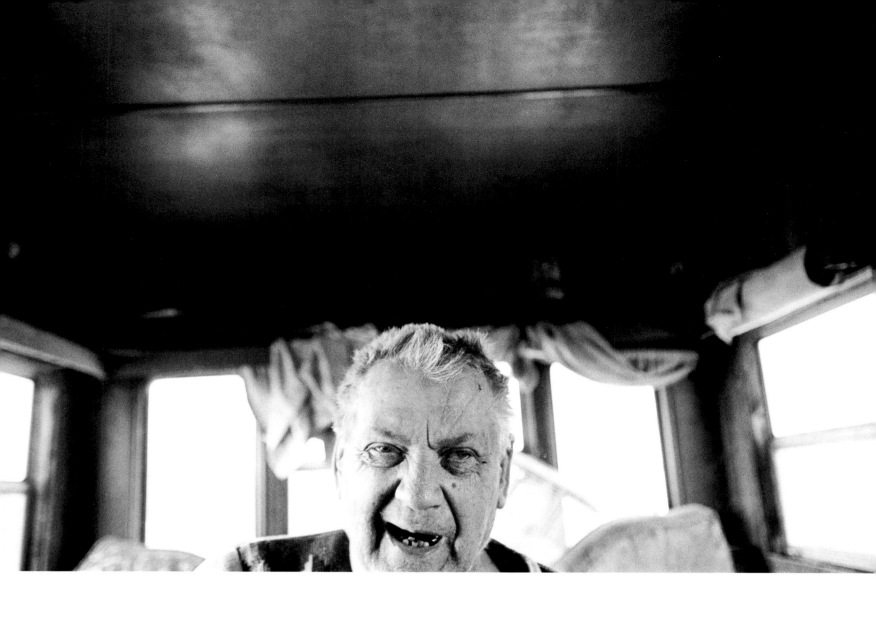

Previous pages: After a storm, McGregor, 2003; Patriotism, Des Moines, 2006; Family at the Eagle's Nest on a Saturday afternoon, Coppock, 2006
Above: Kenneth Zillmer lives alone in a trailer surrounded by cornfields, Wellman, 2003; *Opposite:* The Miller family and friends before sunrise on
the opening day of deer season, Kalona, 2005. A yearly ritual, the hunt allows the Millers to pickle deer meat to help offset food costs.

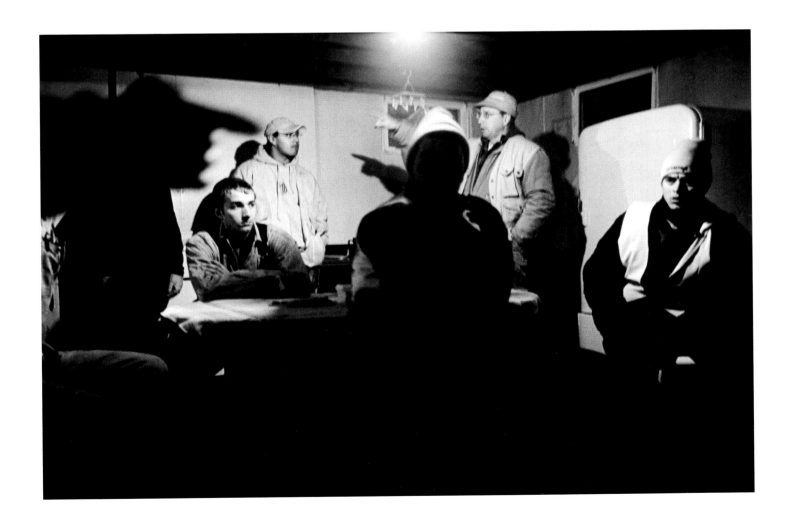

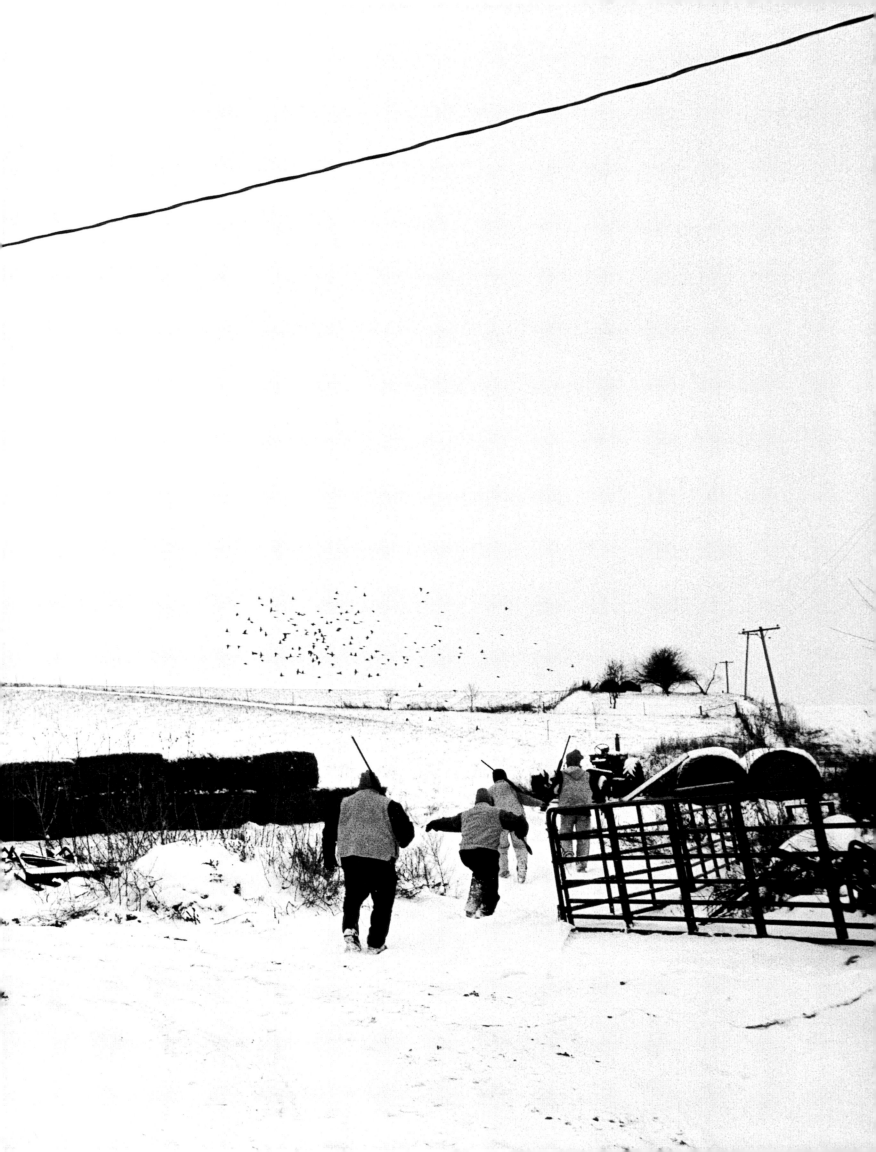

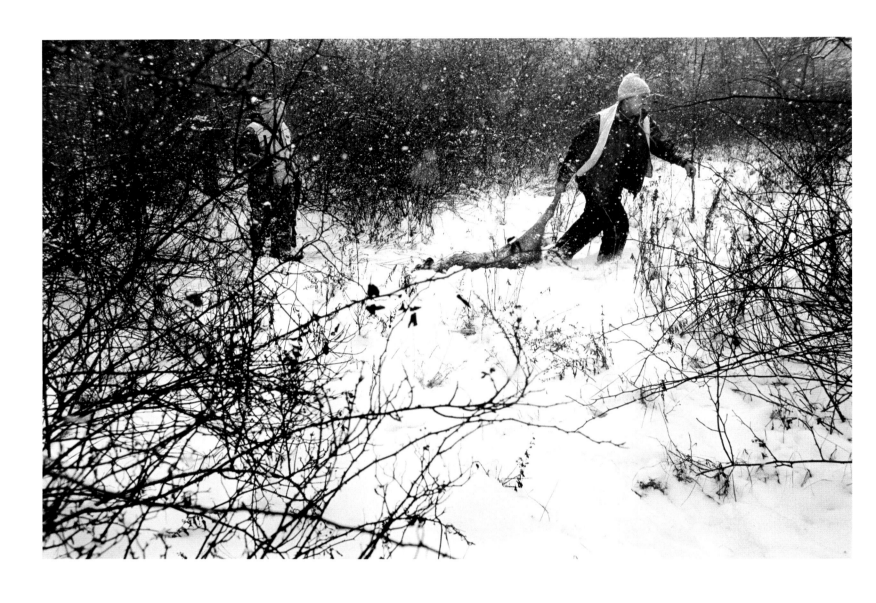

Previous pages: Leslie Miller trails behind his son, Freeman, and friends while crossing a pasture during shotgun season, Kalona, 2005

Above: Allen Miller drags a young doe from the woods, Kalona, 2005

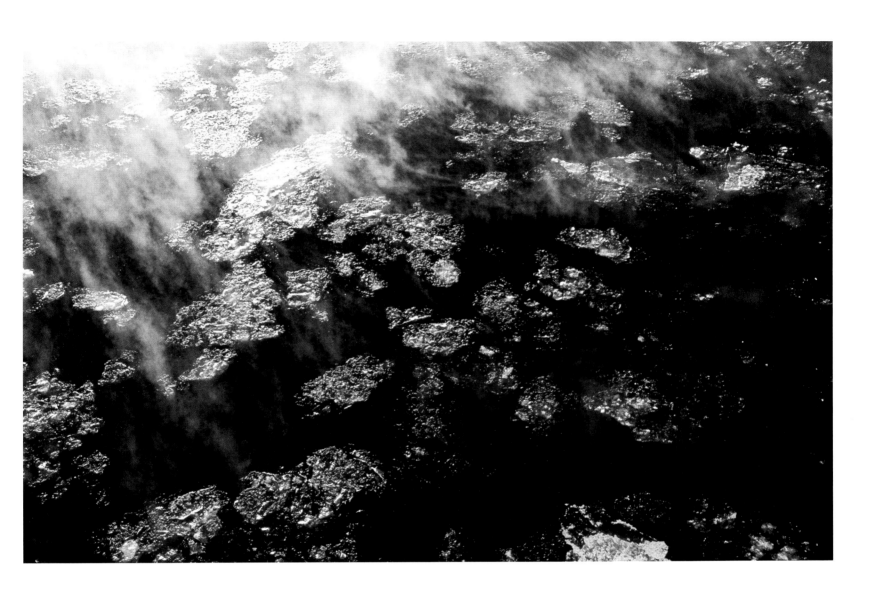

Ice breaks up on the Cedar River during the spring thaw, Linn County, 2003

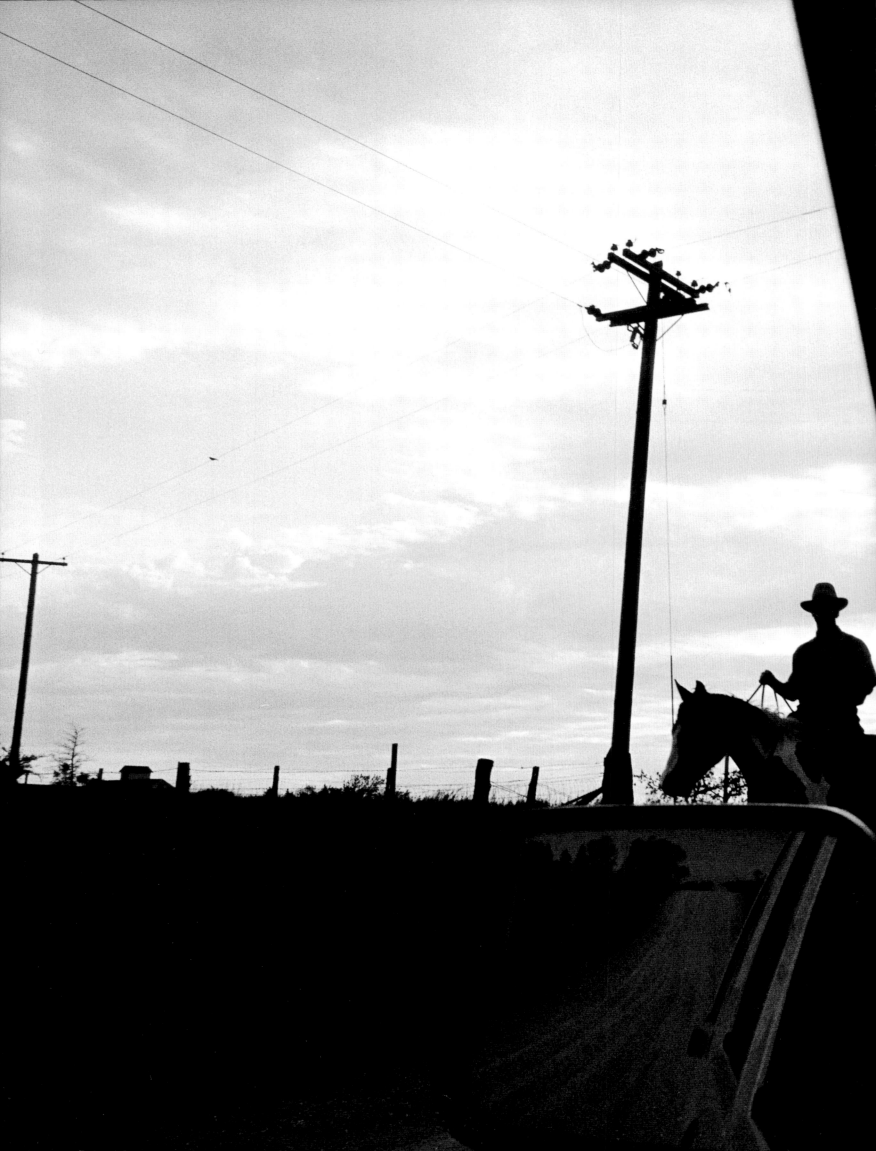

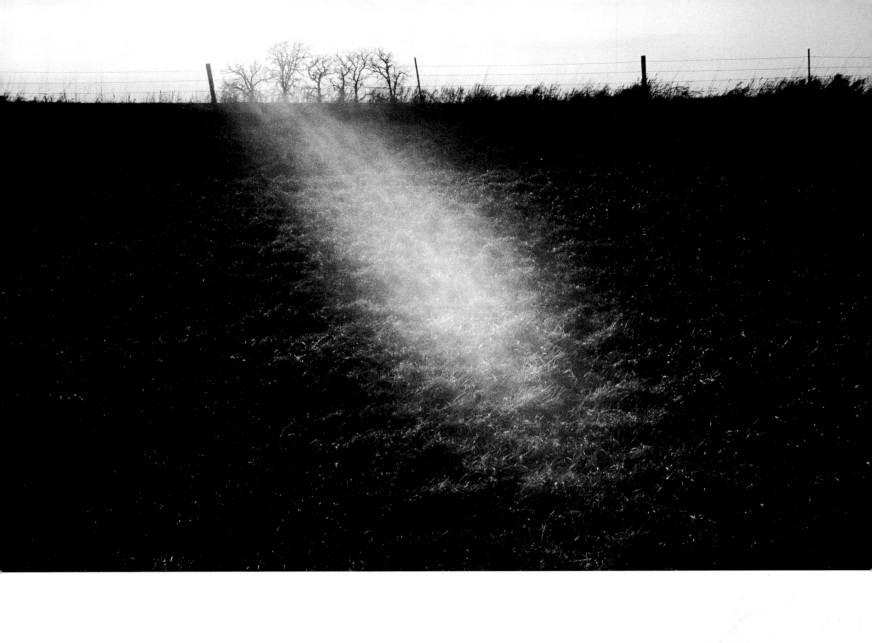

Previous pages: An Amish man on horseback along a gravel road, Johnson County, 2005; *Above:* Sunlight across an open field, central Iowa, 2004

Opposite: Eleven-year-old Karlin Stutzman climbs out of a pickup to help his brothers slaughter a calf, Kalona, 2003

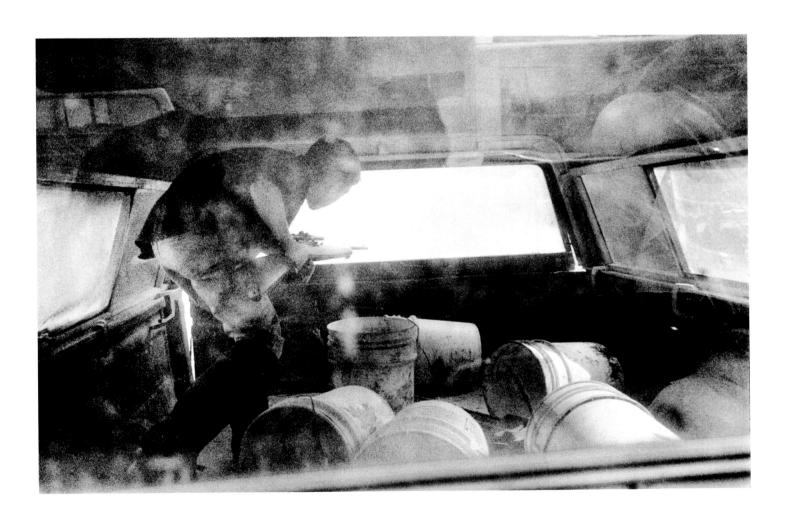

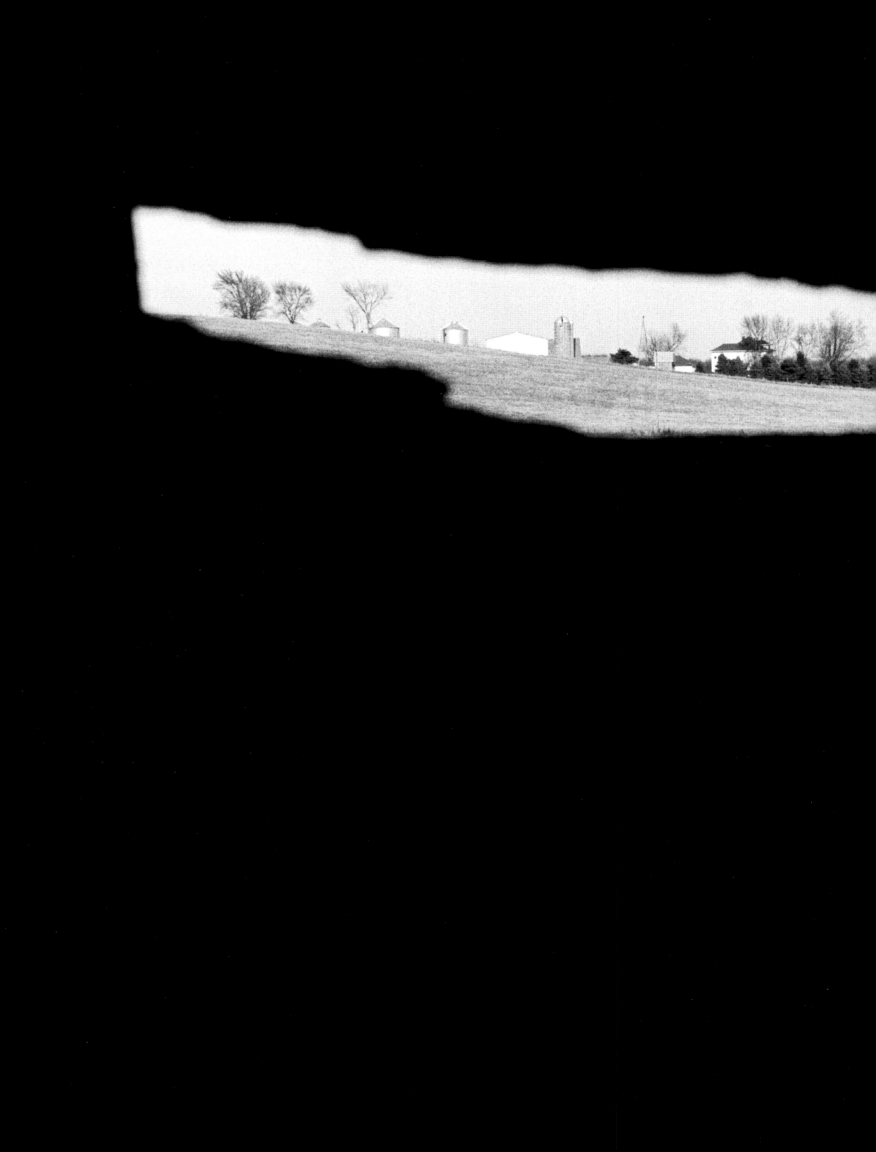

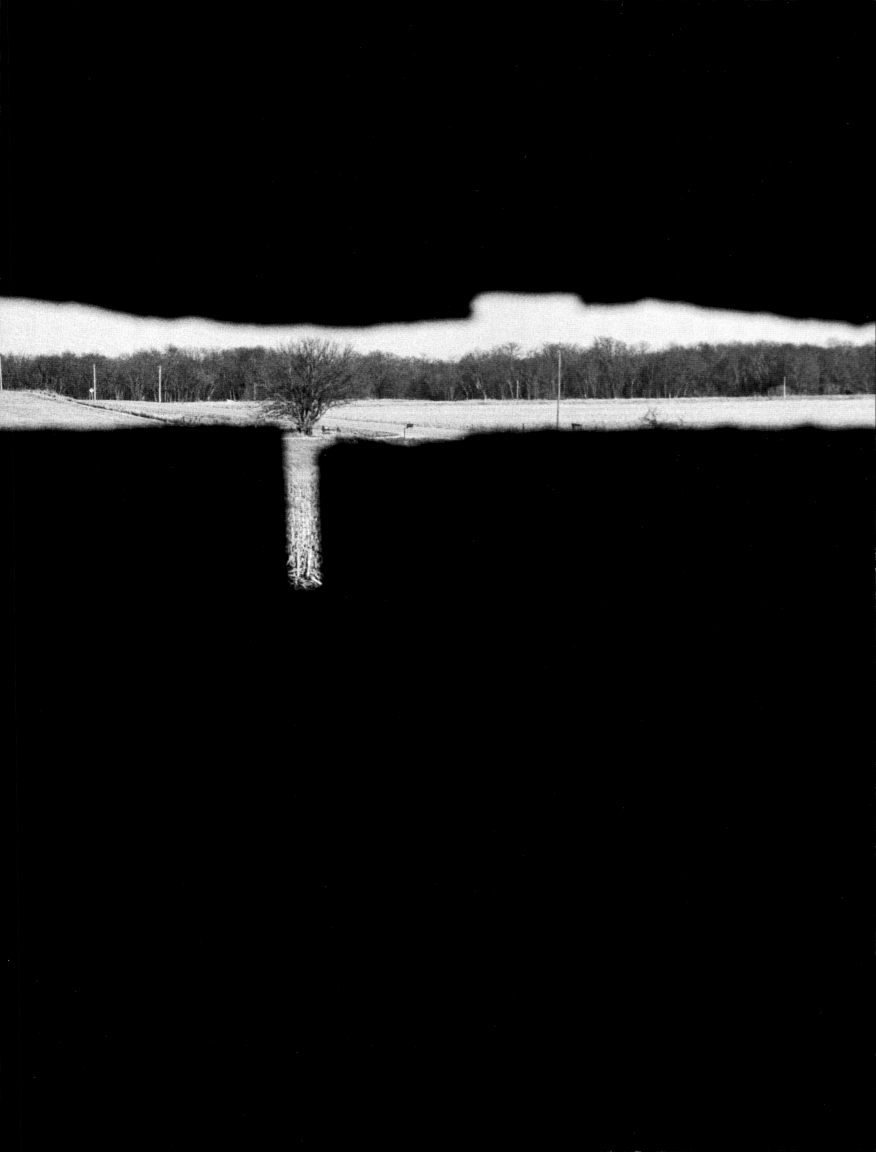

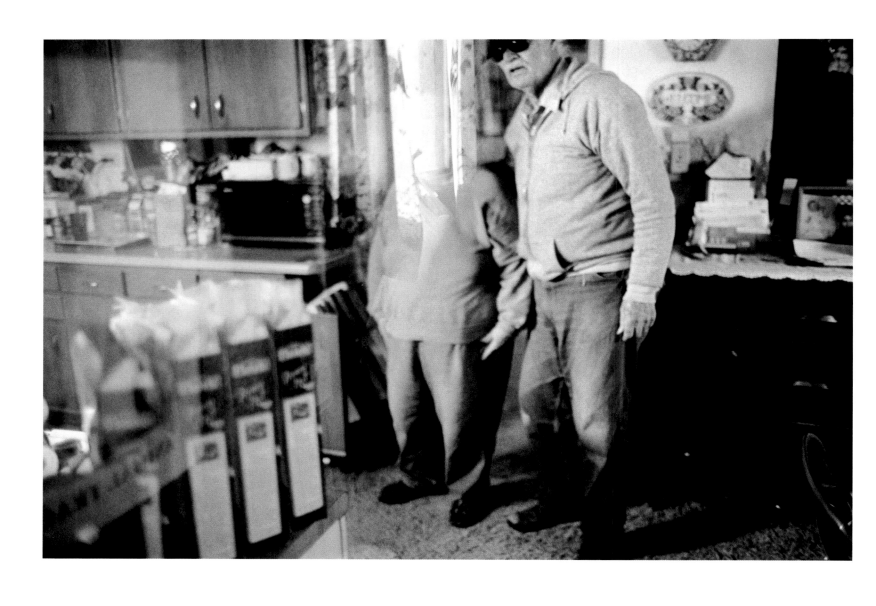

Previous pages: View of farm fields, Johnson County, 2003; *Above*: Harry and Helen Phelps, Sutliff, 2005. Harry took care of his wife,

Helen, who suffered from Alzheimer's, until she died at home. Harry, at seventy-seven, runs his small cattle operation alone.

Opposite: Harvest on the Miller family farm, Kalona, 2005

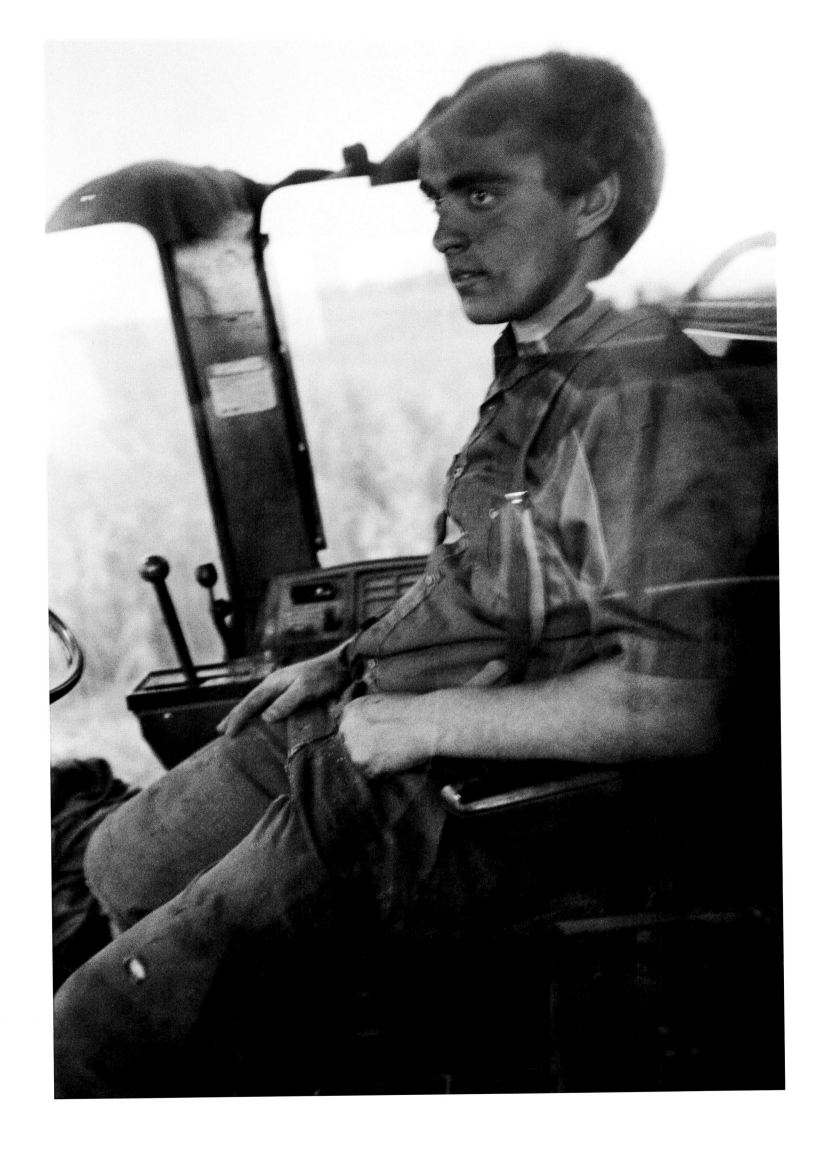

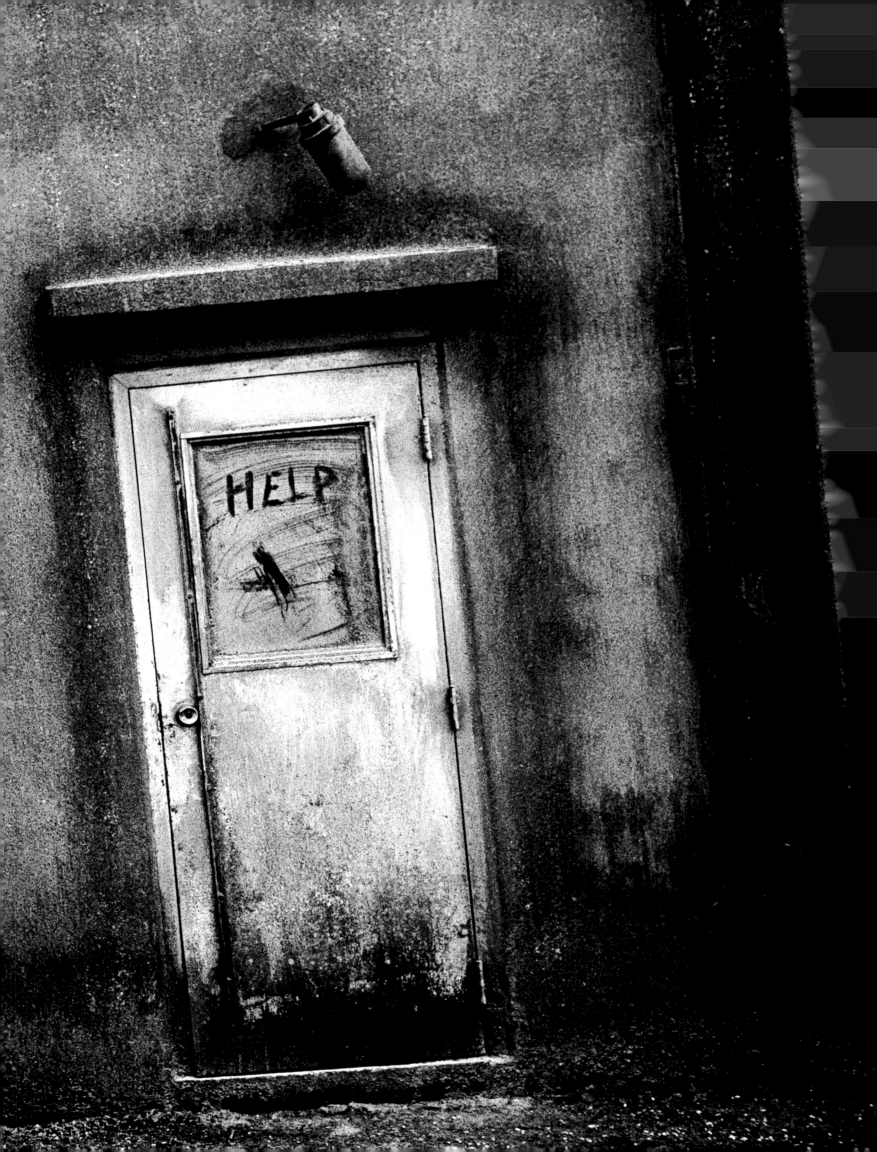

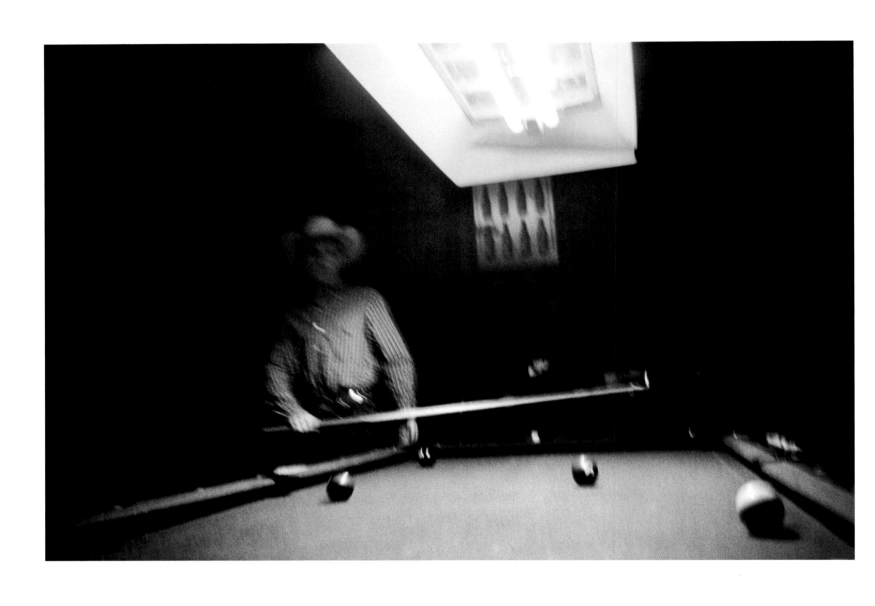

Previous pages: Grain elevator, Frytown, 2003; *Above:* Cowboy playing pool at a bar, Ottumwa, 2004

Opposite: top, Brothers share a smoke at a gun range, Swisher, 2002; *bottom,* Hot Body Contest, Ottumwa, 2004

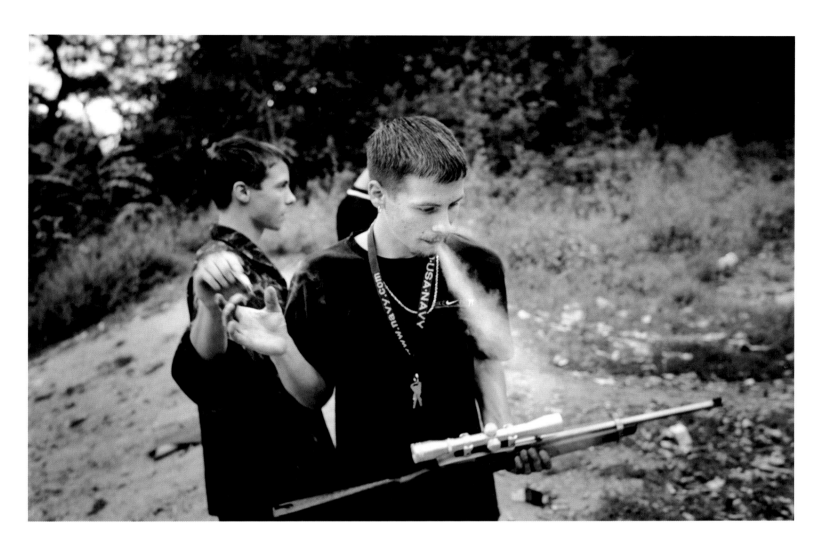

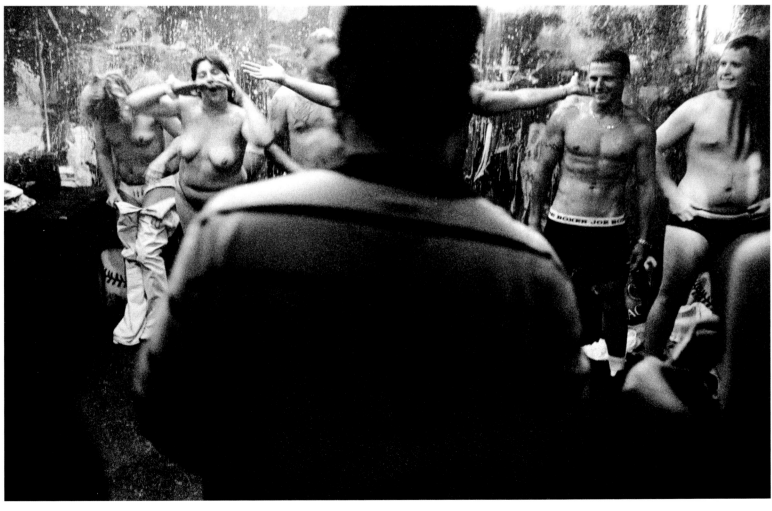

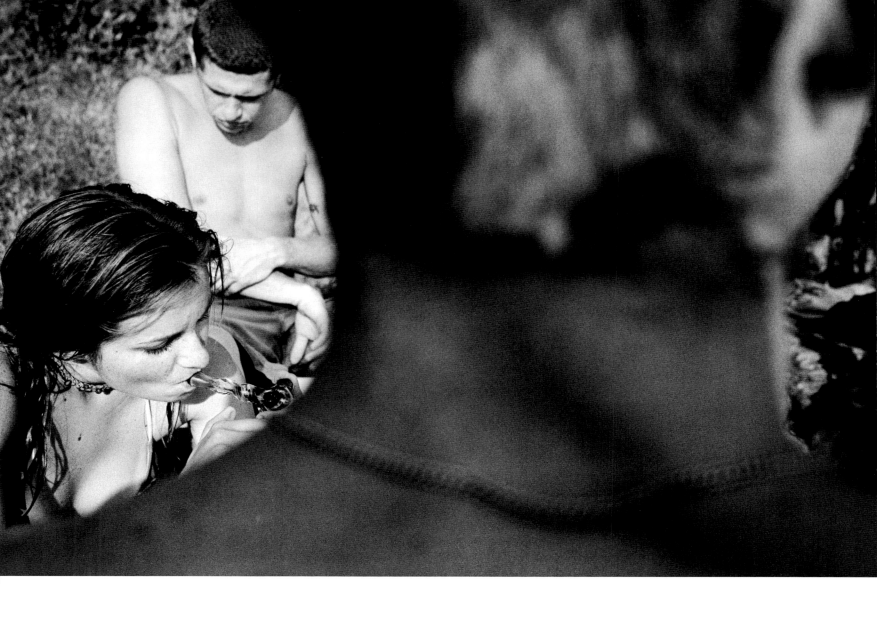

Above: Partying along the Iowa River, North Liberty, 2004; *Opposite:* Deer hide rotting inside a wheelbarrow, Kalona, 2003

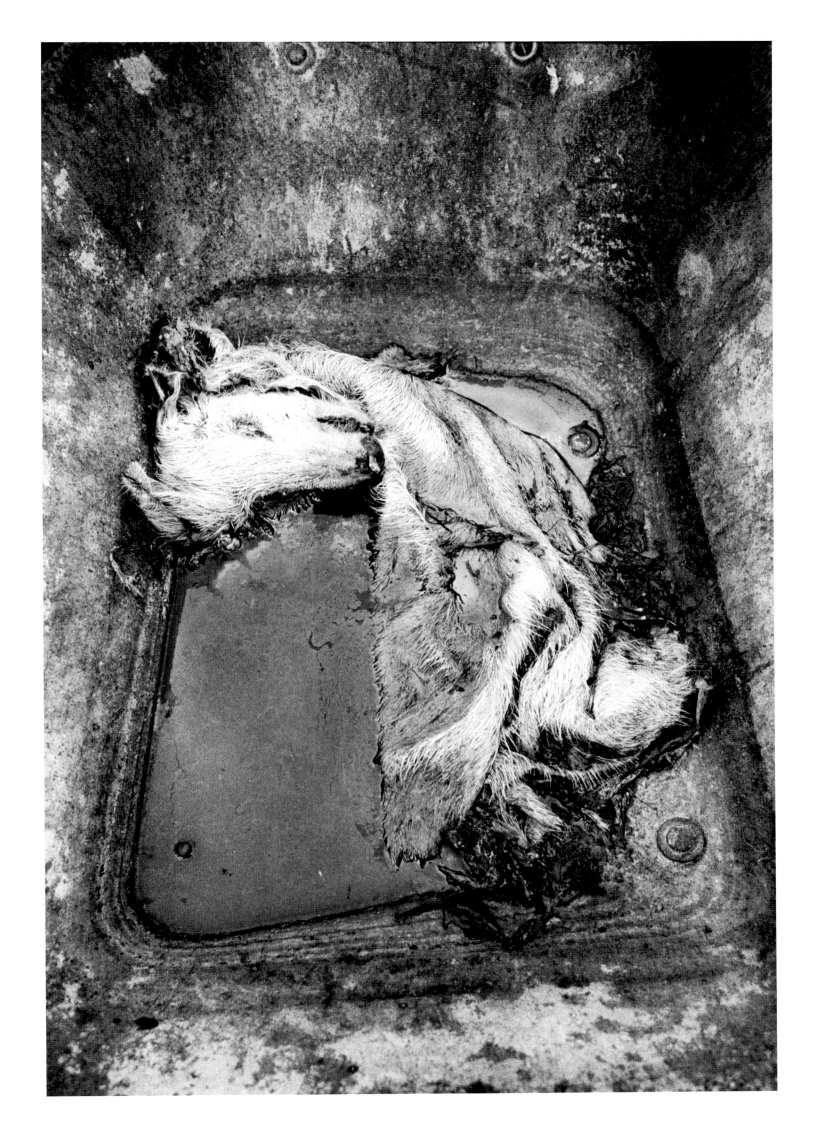

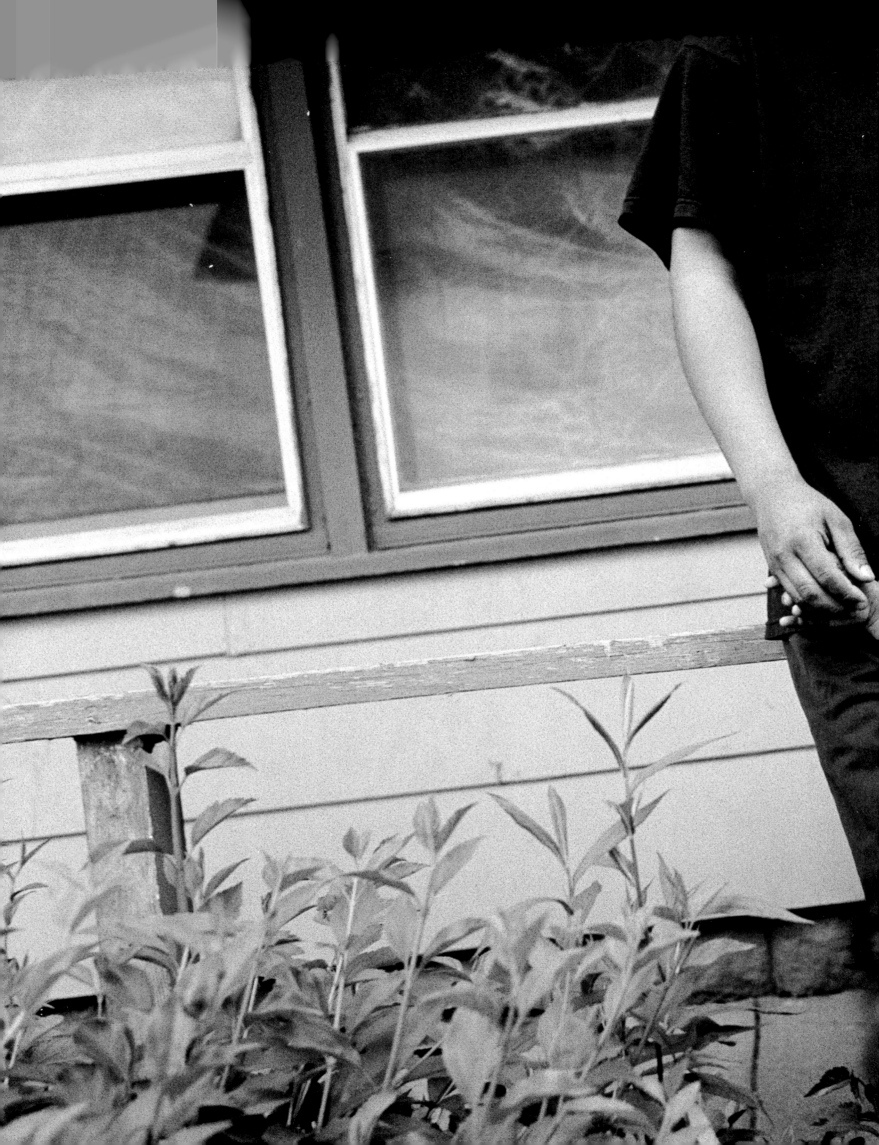

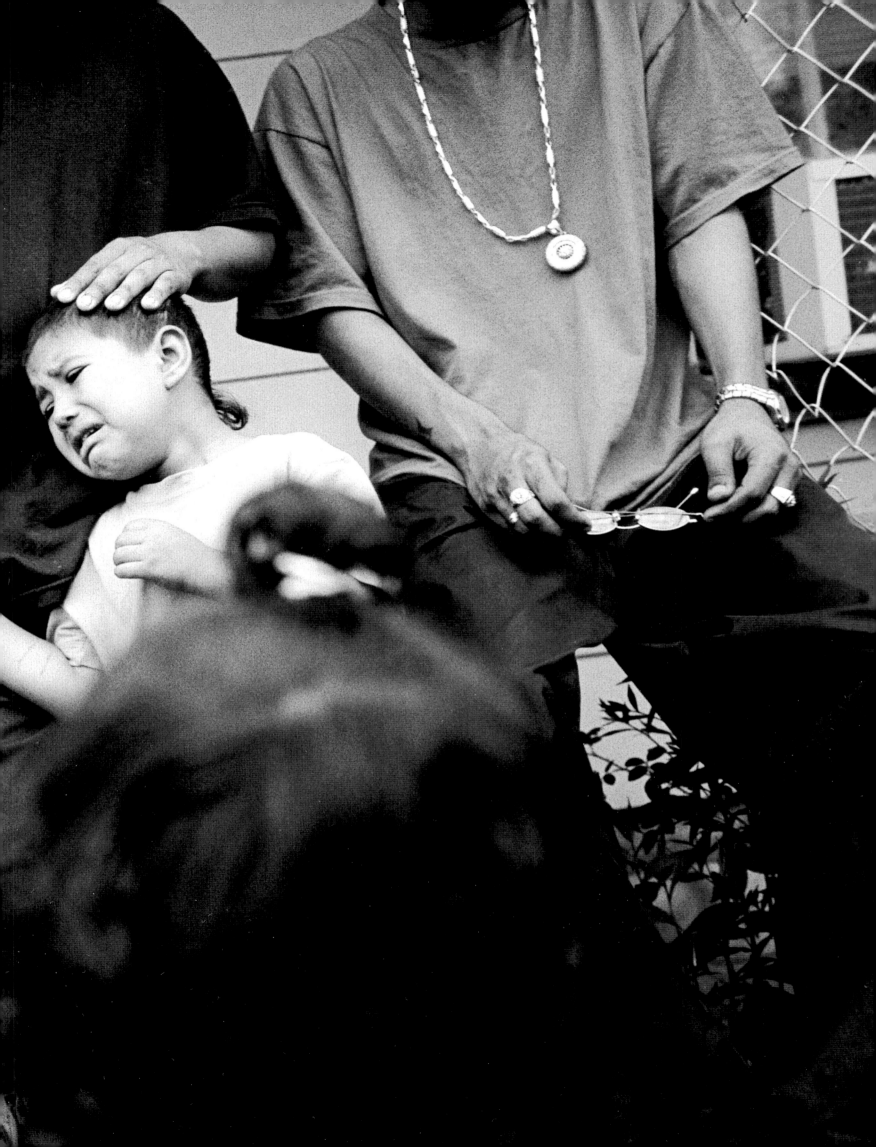

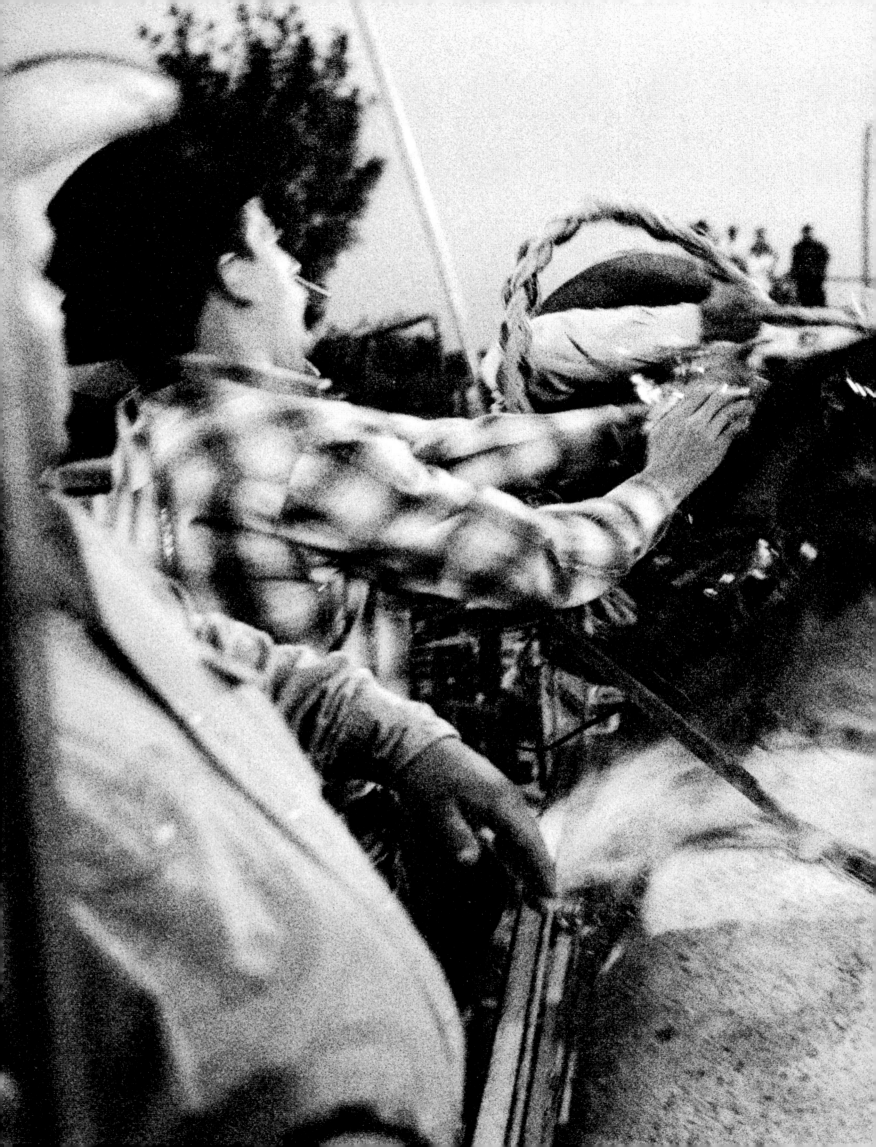

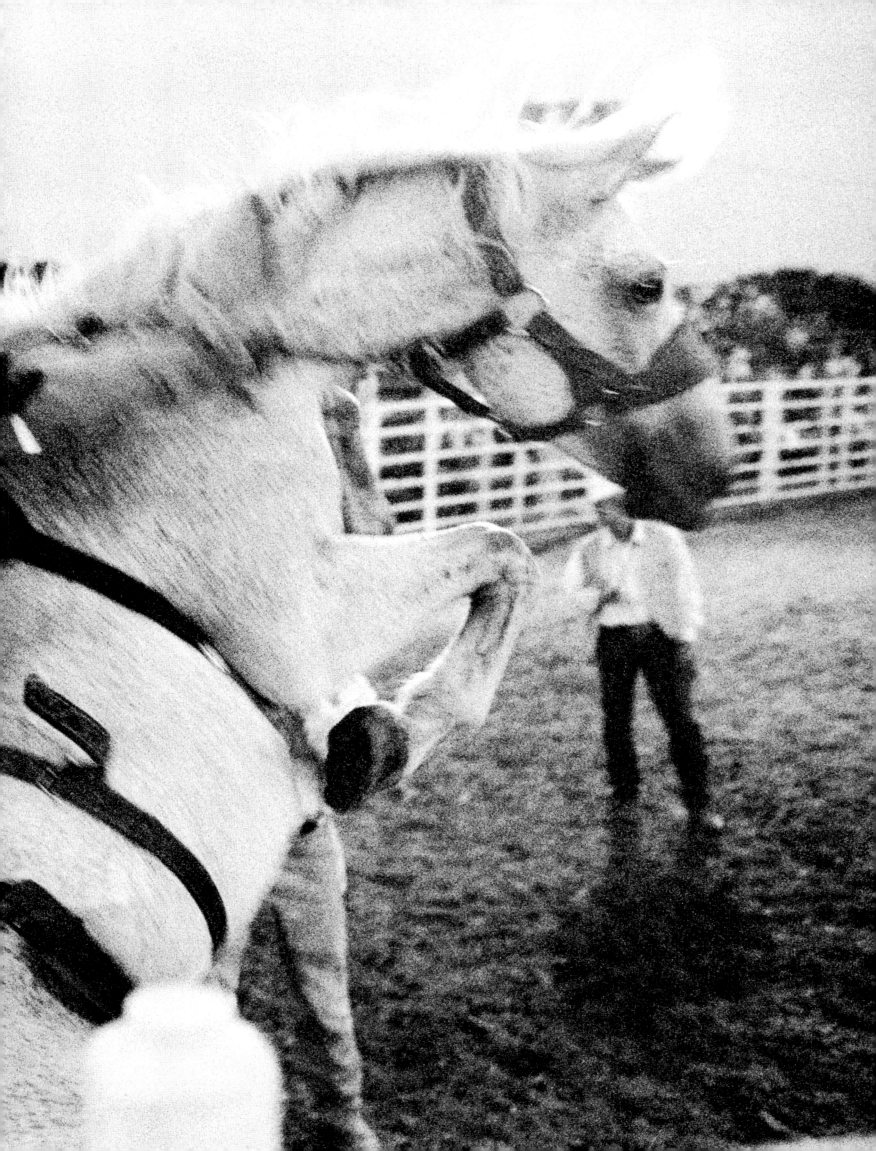

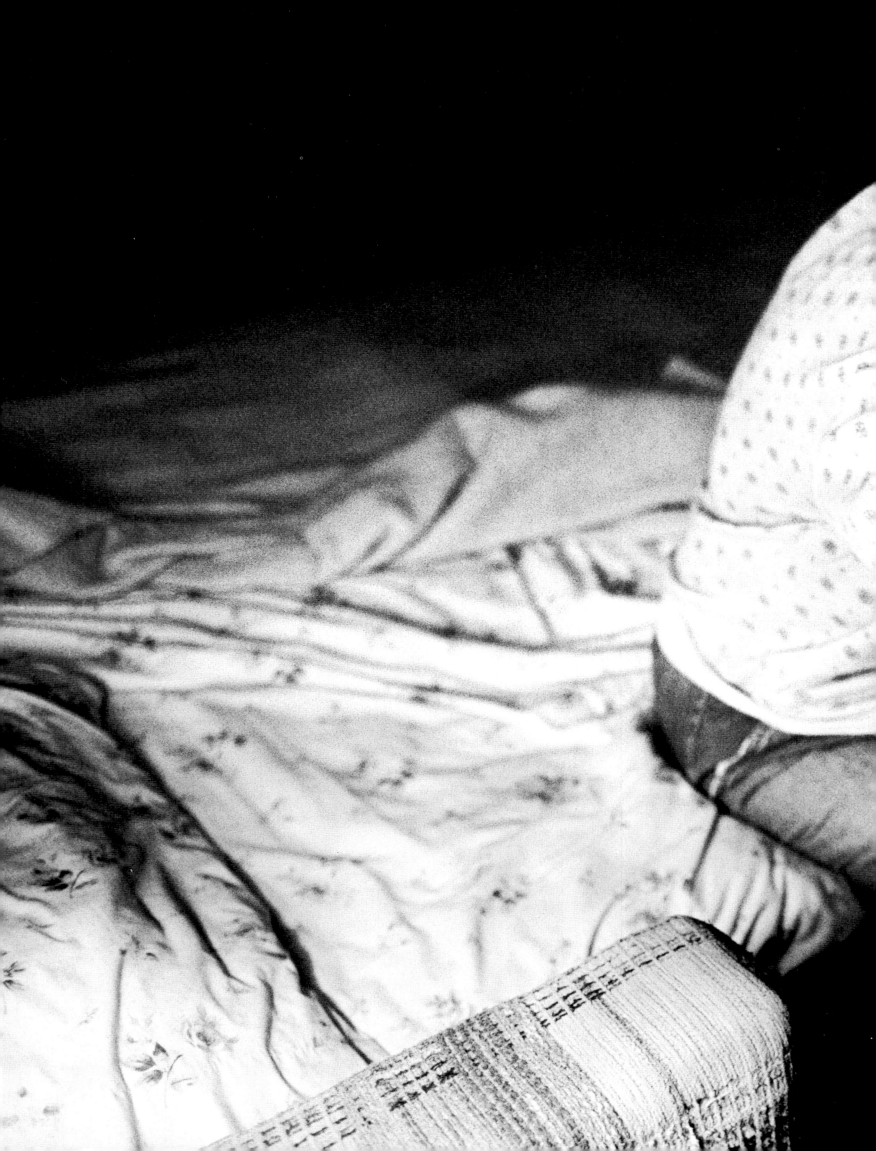

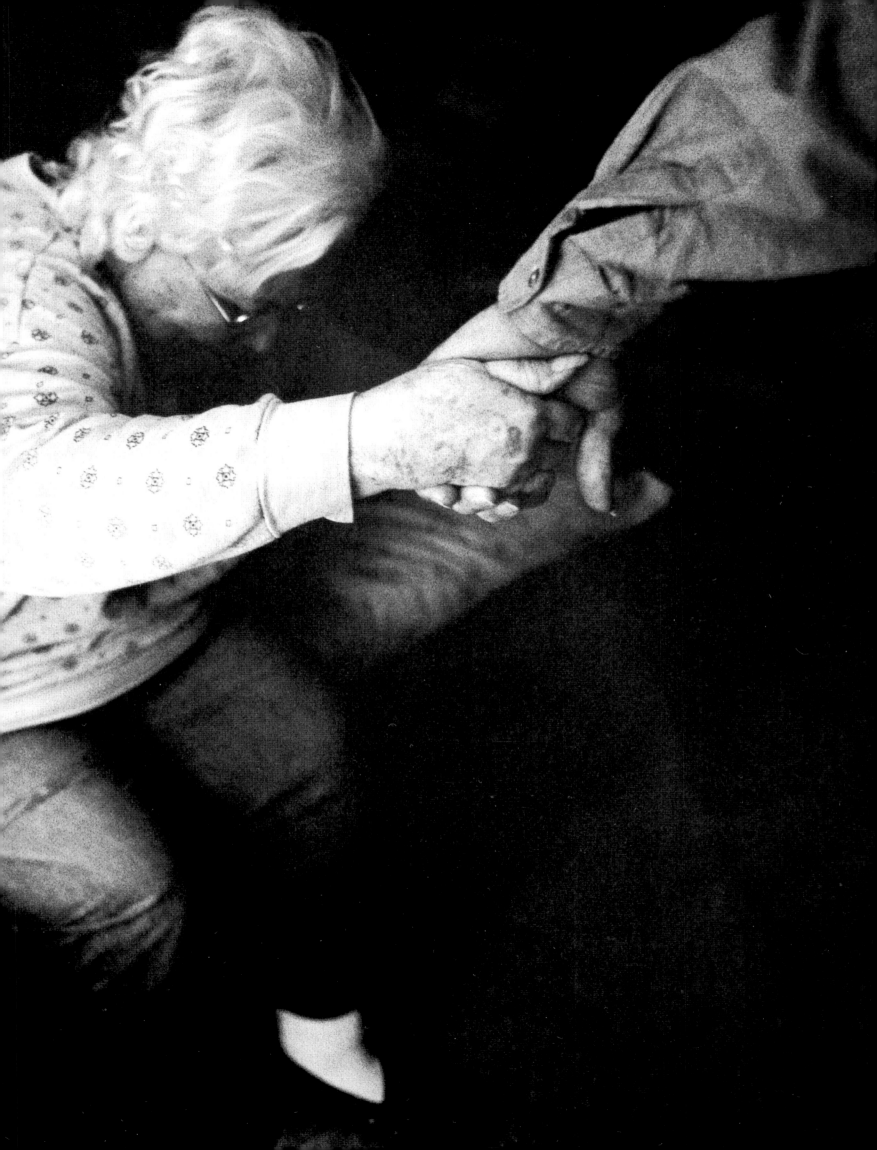

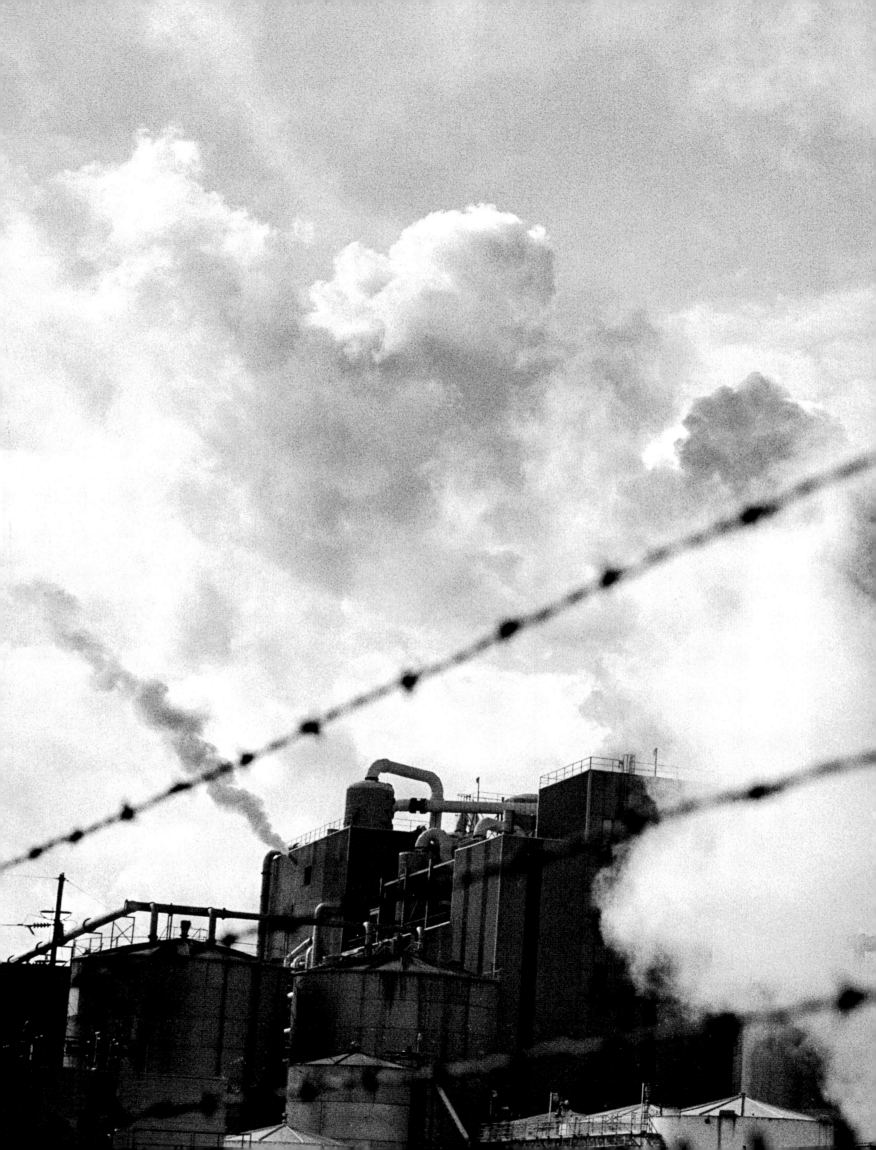

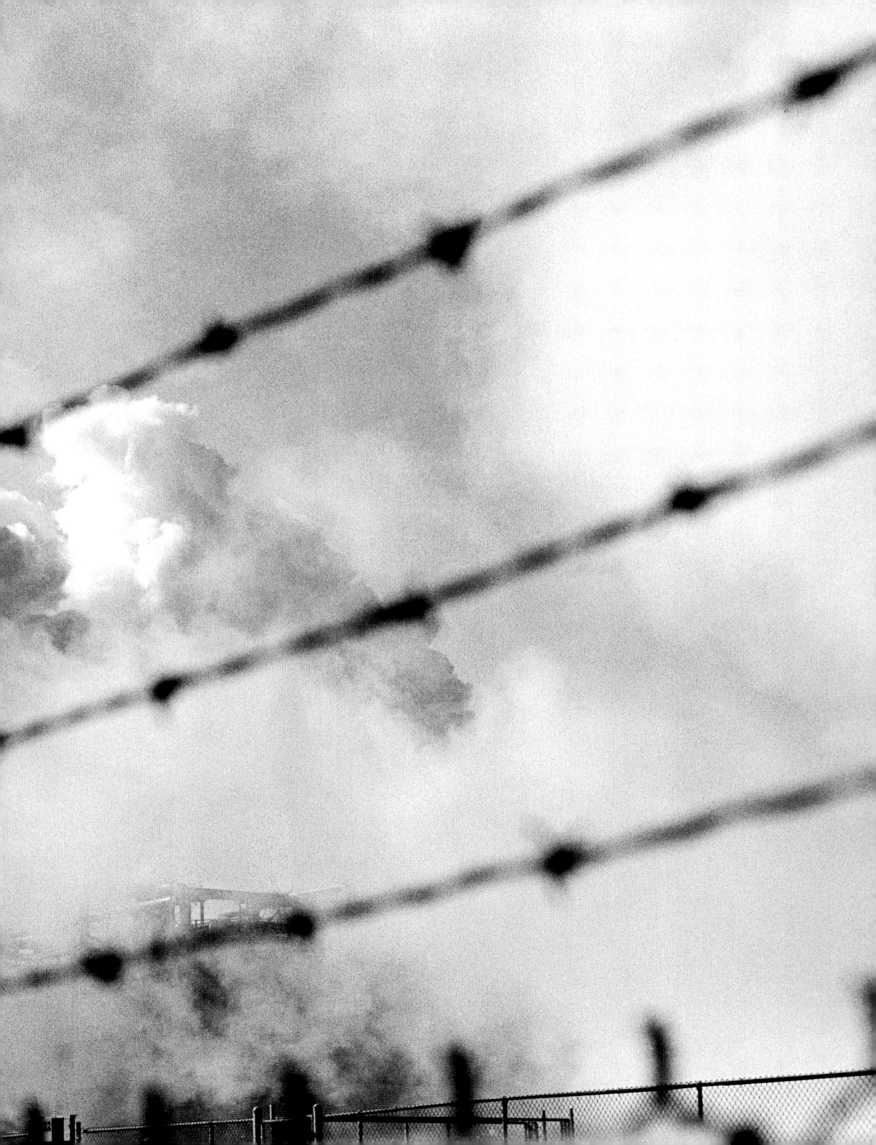

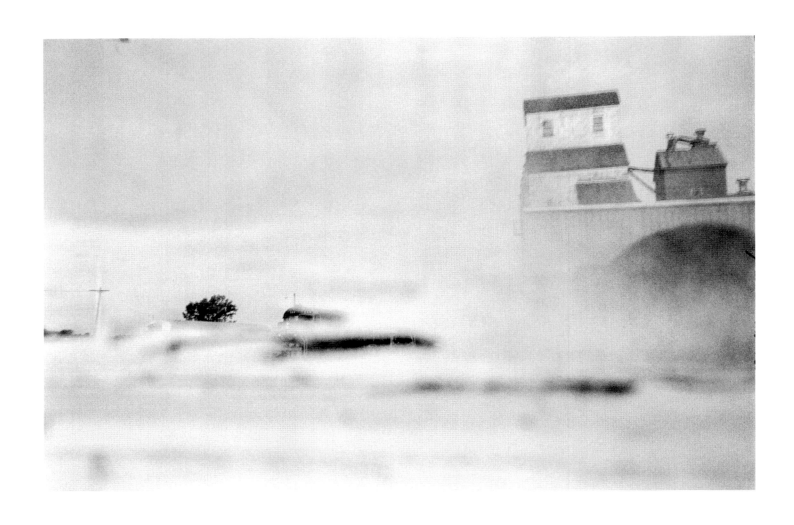

Previous pages: A father comforts his son, Columbus Junction, 2004; Rodeo, Monroe County Fairgrounds, Albia, 2004;
Harry Phelps helps his wife, Helen, Sutliff, 2005; Factory pollution, Linn County, 2003
Above: Grain elevator and abandoned train, Lake Park, 2004; *Opposite:* Blizzard, Johnson County, 2003

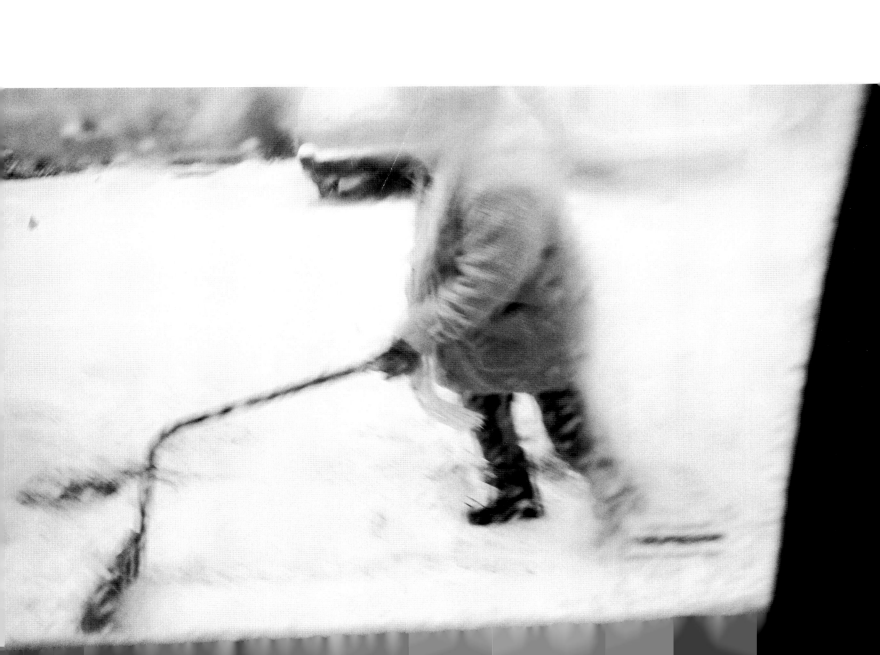

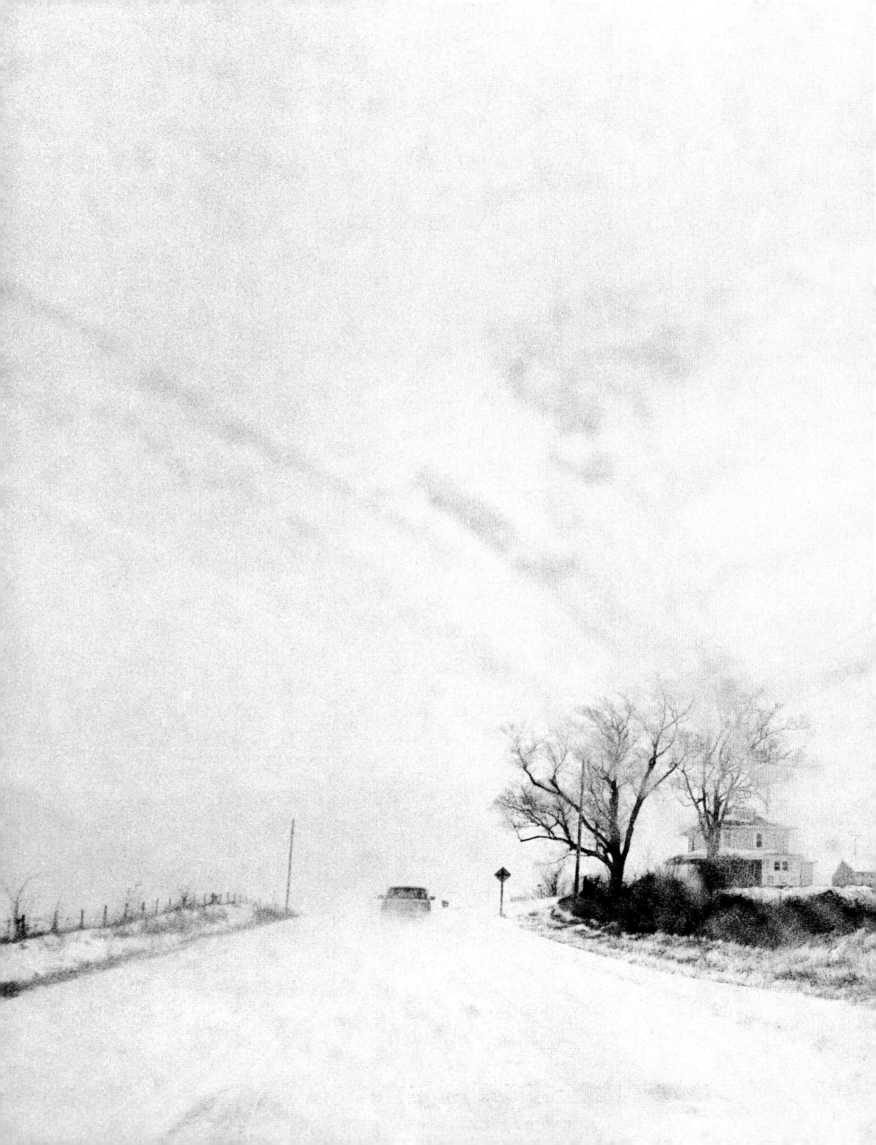

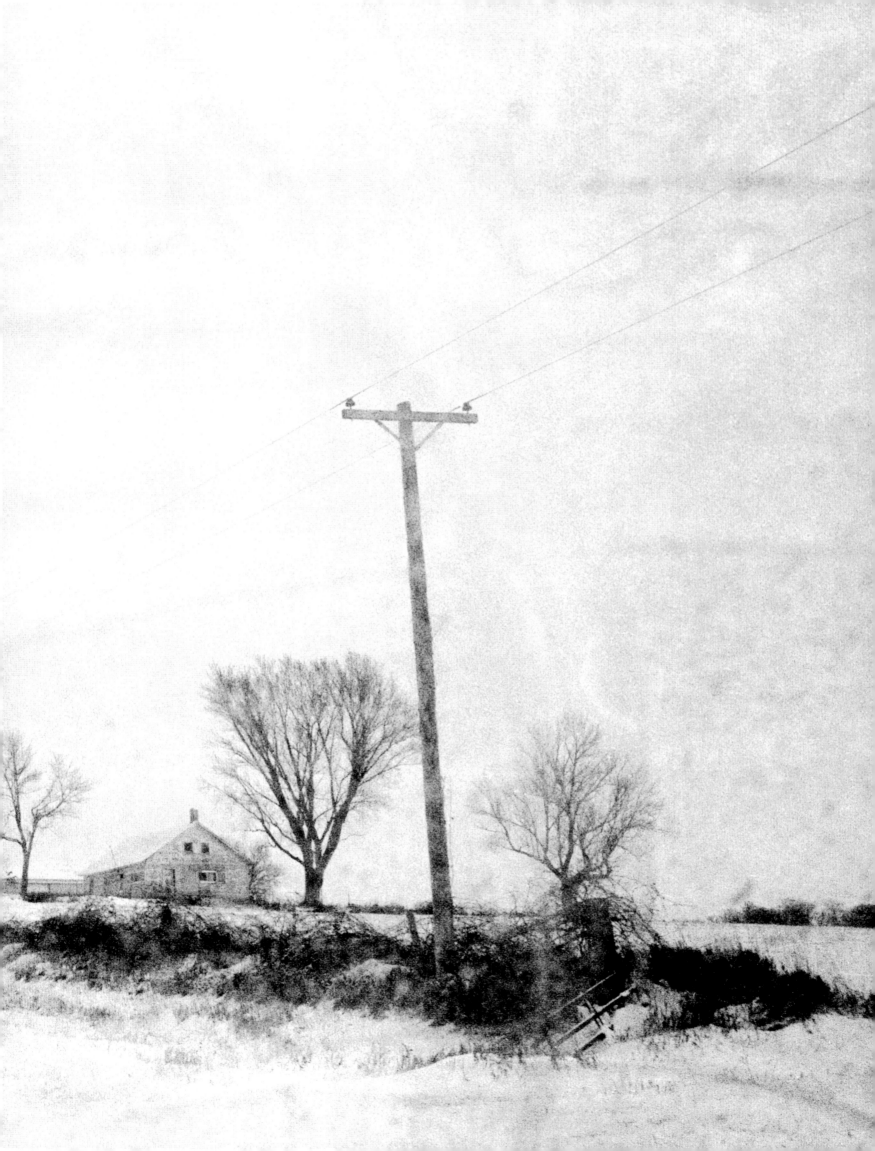

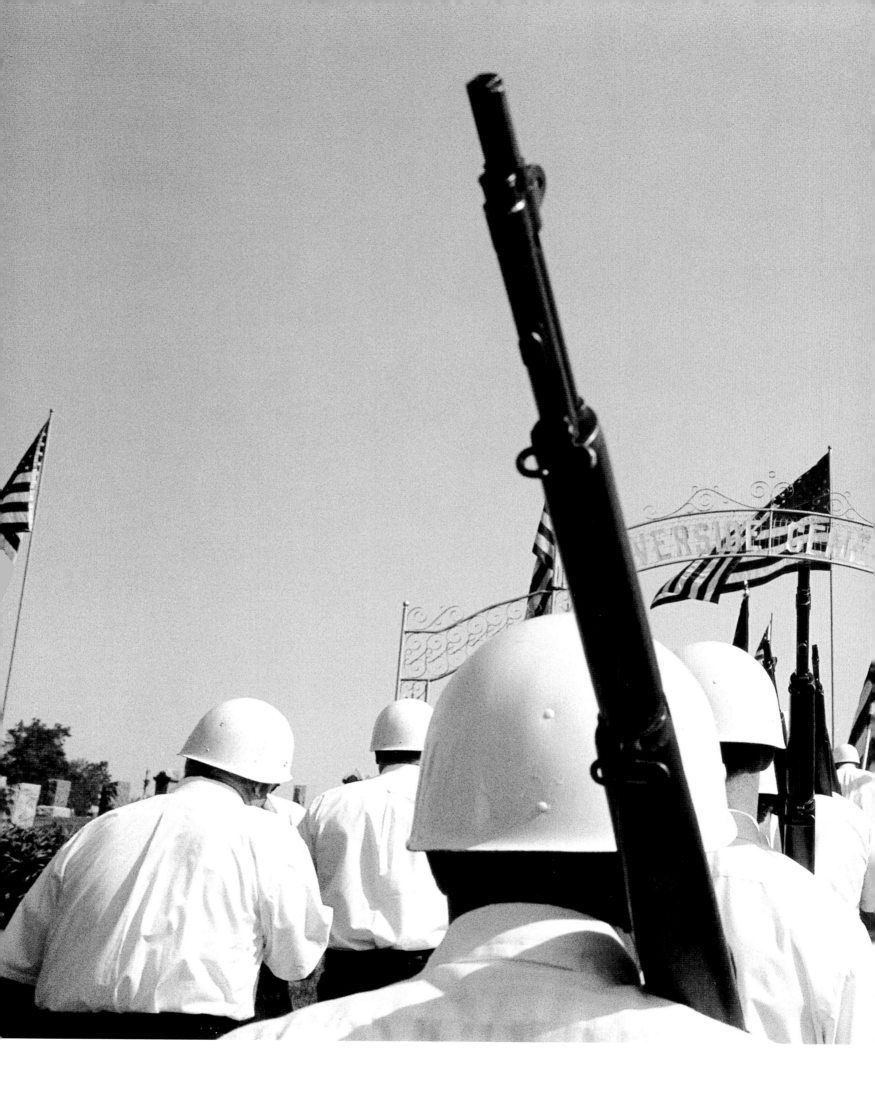

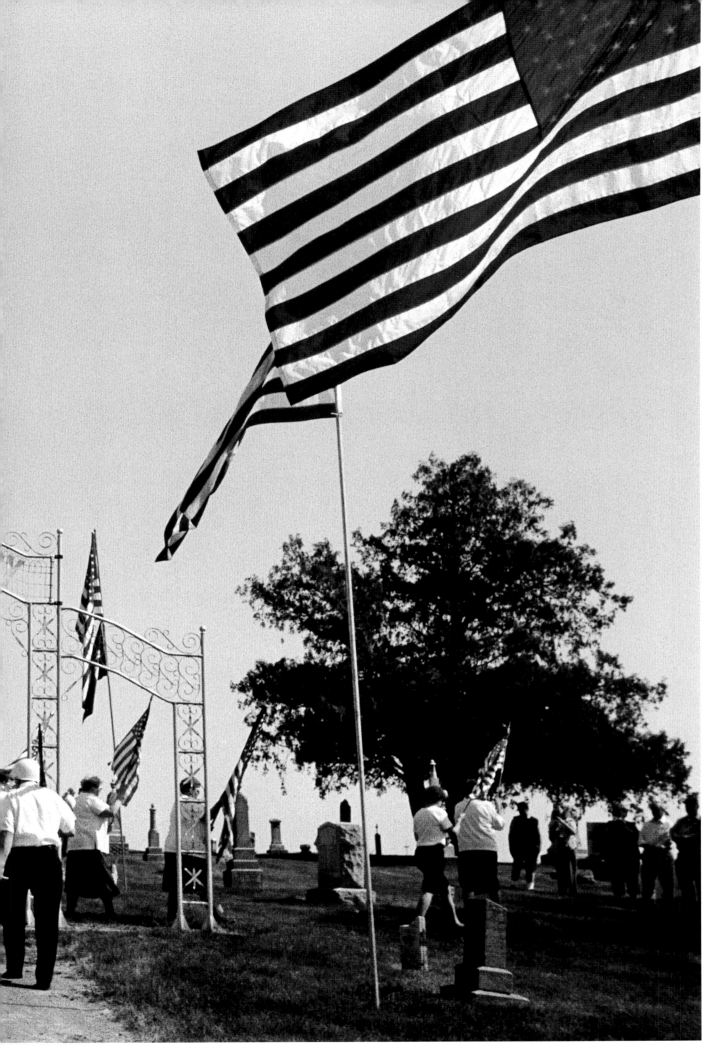

Previous pages: Through the windshield, opening day of deer season, near Kalona, 2005

Above: Members of VFW Post 6414, Memorial Day, Riverside, 2003

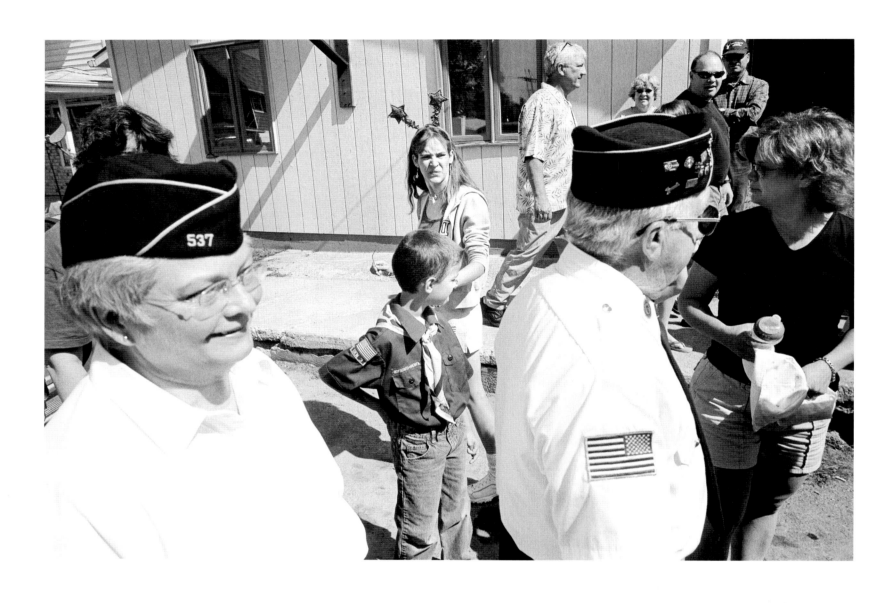

Memorial Day, Oxford, 2005

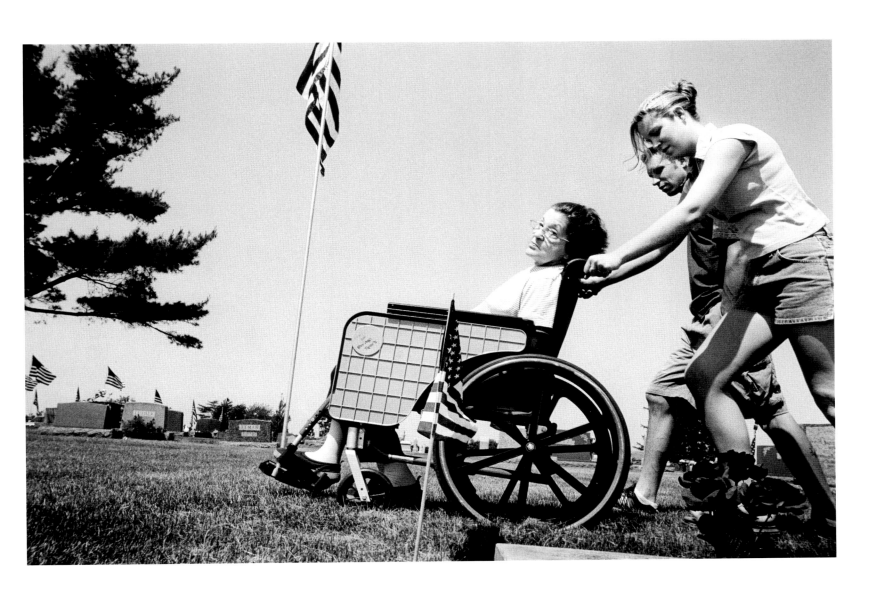

Memorial Day, Lone Tree, 2003

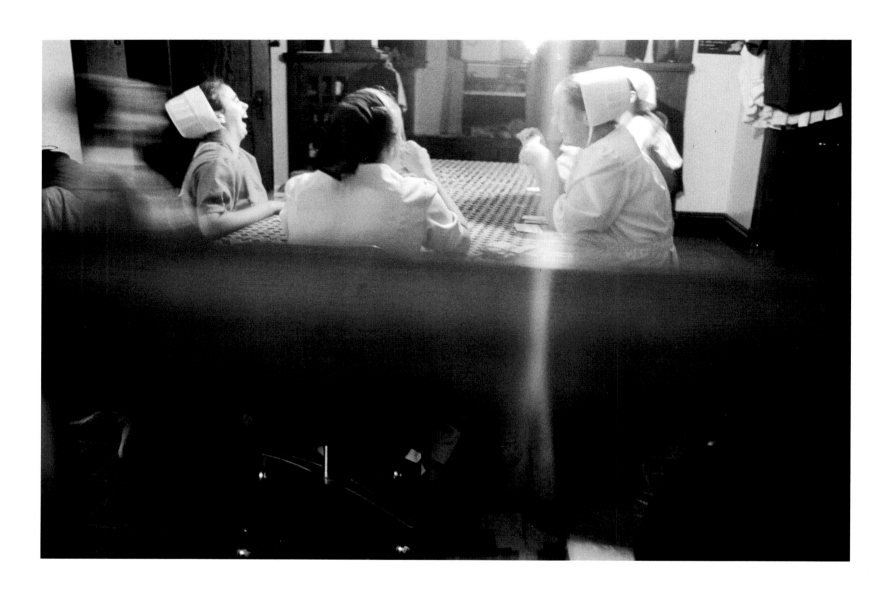

Previous pages: Plastic farm scene, Fort Dodge, 2003

Above: Amish girls laugh as they play a Bible card game during harvest on the Miller family farm, Kalona, 2005

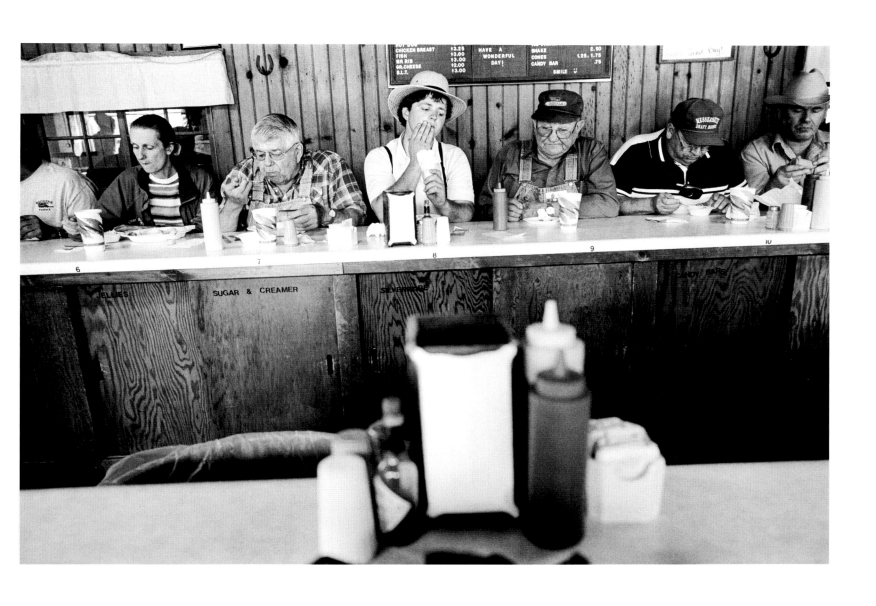

Sale Barn Café, Kalona, 2005

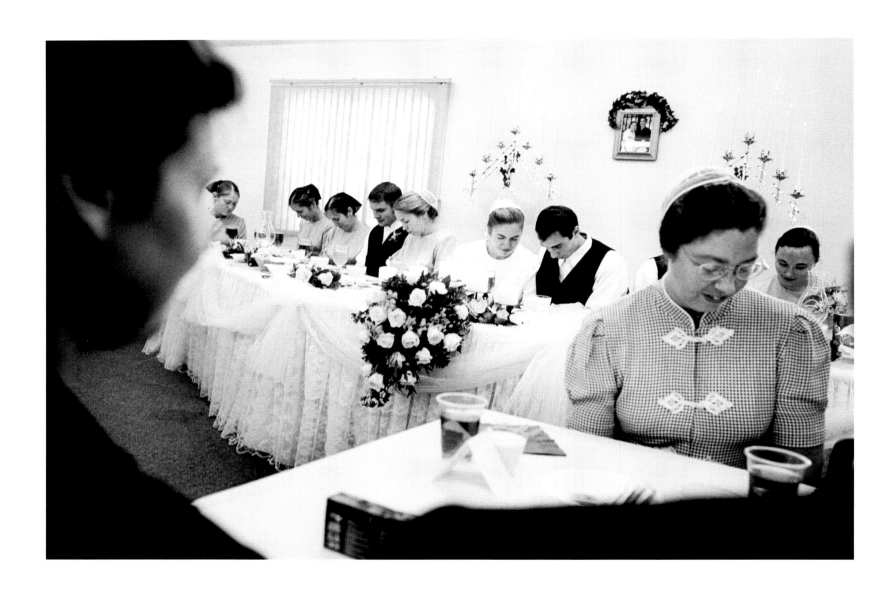

Beachy Amish wedding, Kalona, 2004

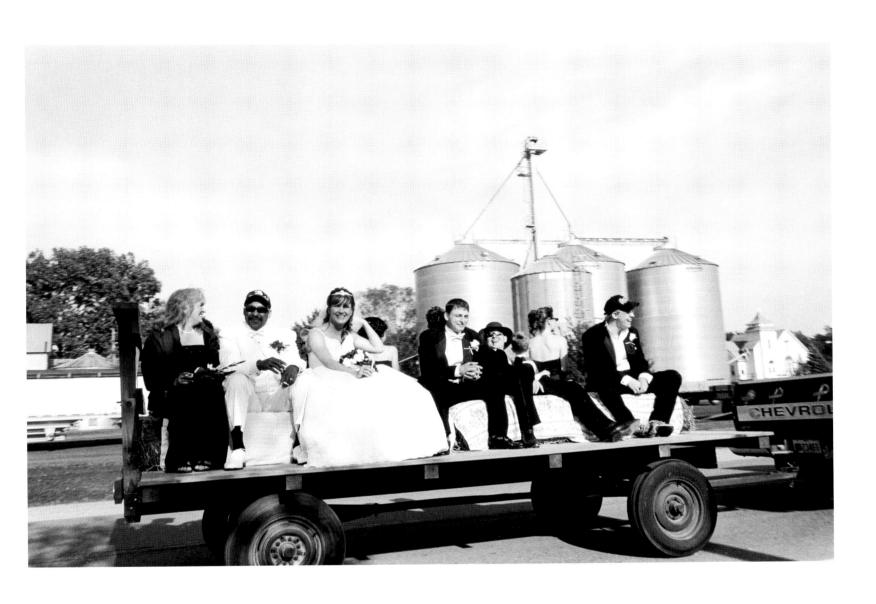

Wedding day, Conesville, 2006

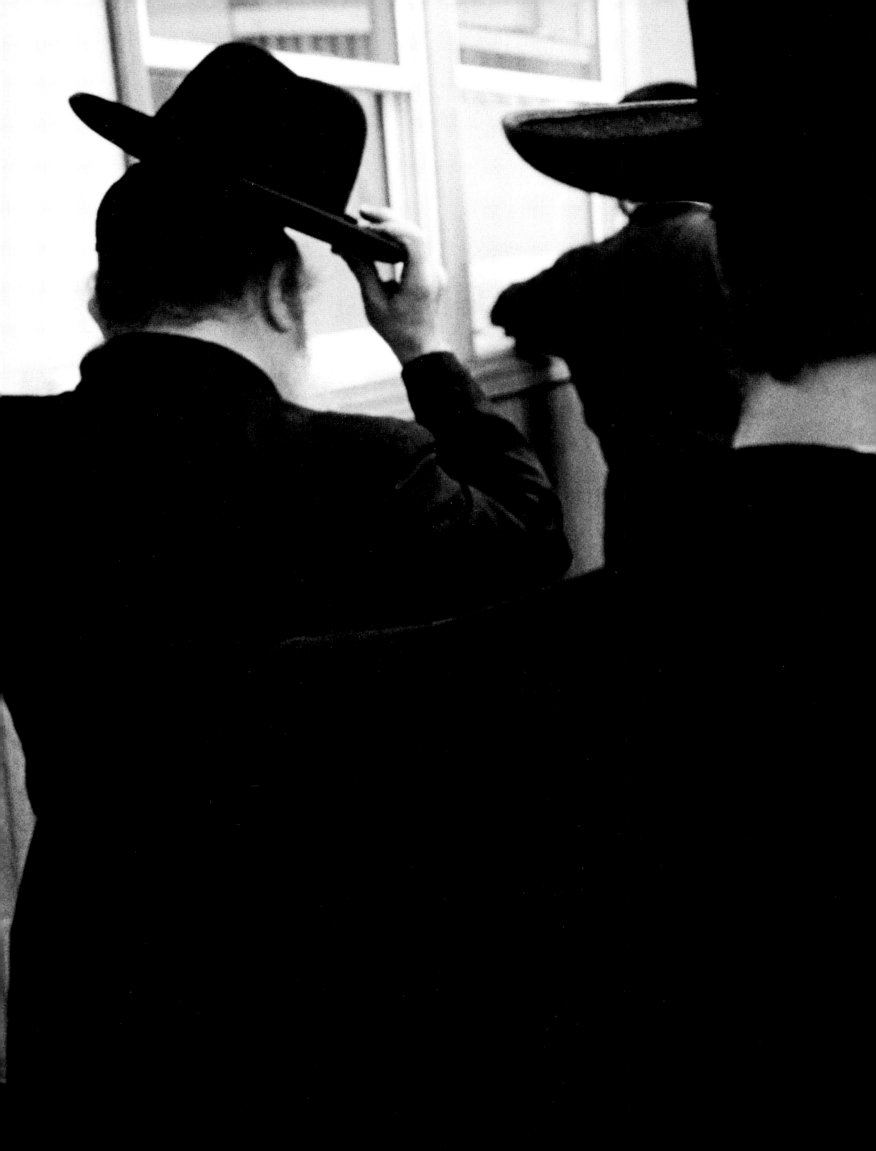

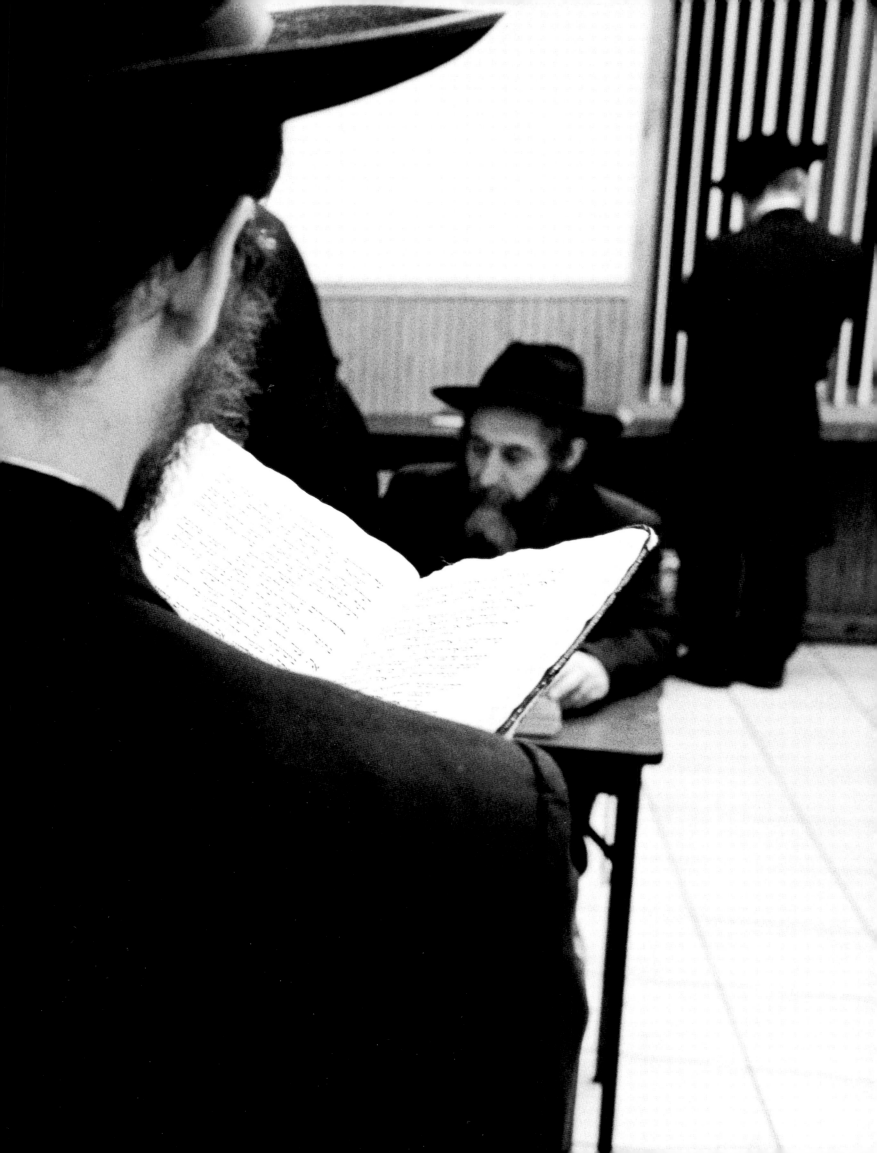

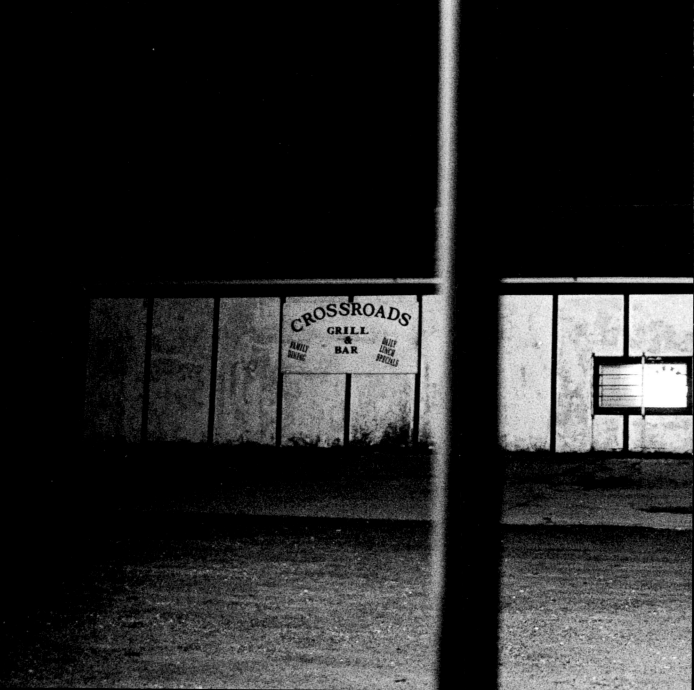

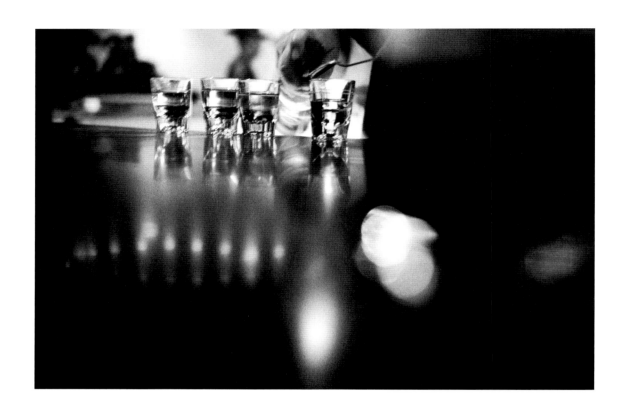

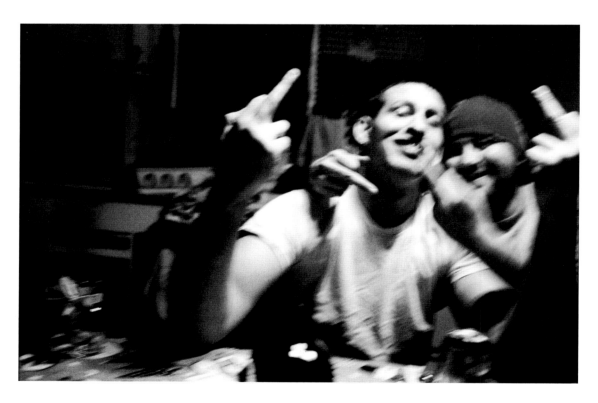

Previous pages: Lubavitcher Hasidic Jews praying, Postville, Iowa, 2003. Lubavitcher Hasidic Jews bought a closed
meatpacking plant in Postville, converting it into a kosher slaughterhouse.
Crossroads Grill and Bar, South English, 2006; *Top:* Four shots at the American Legion, Solon, 2006
Bottom and opposite: Party at a farmhouse, Johnson County, 2006

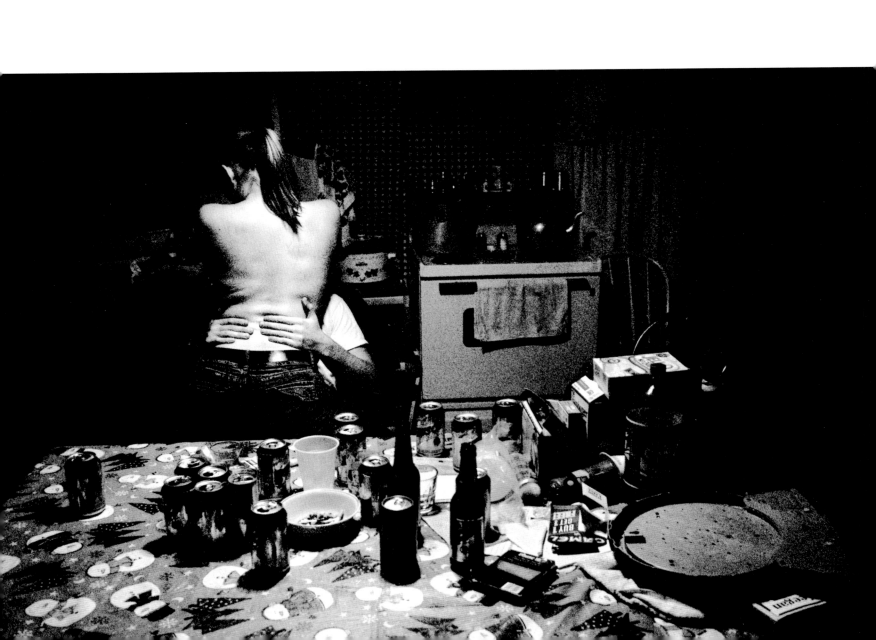

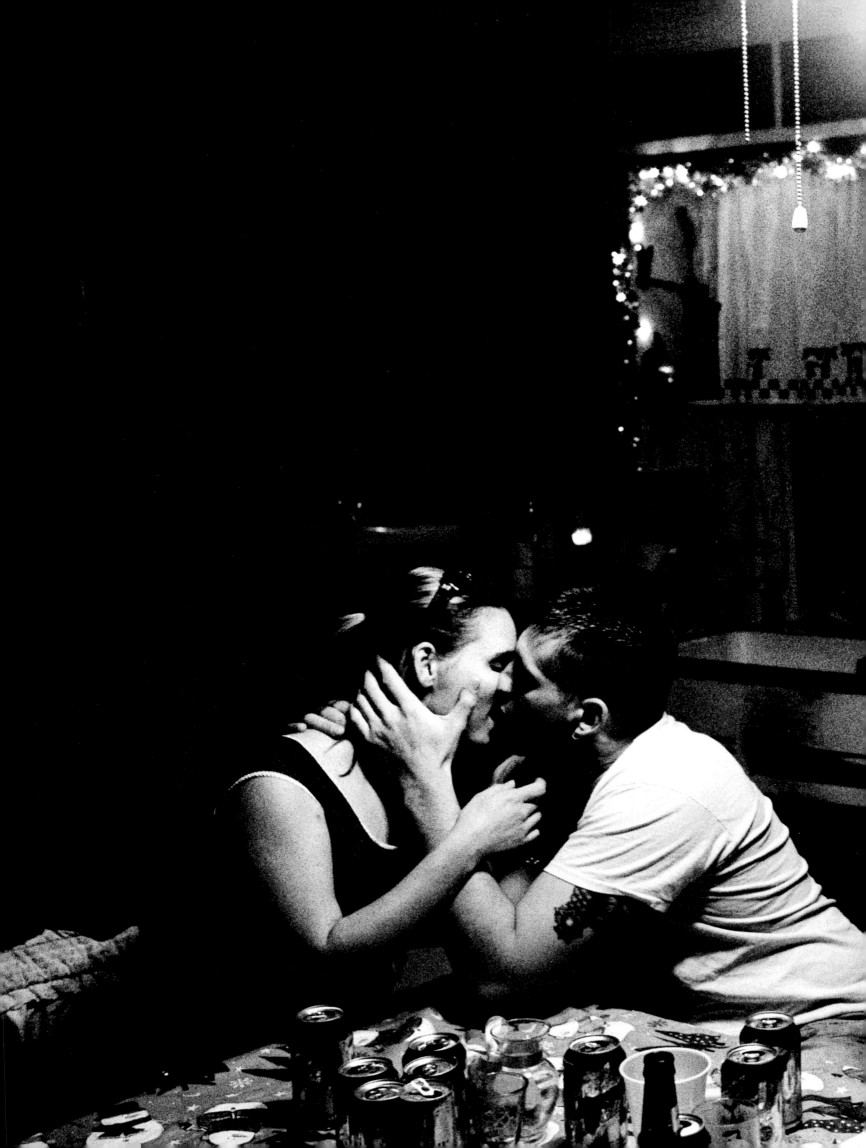

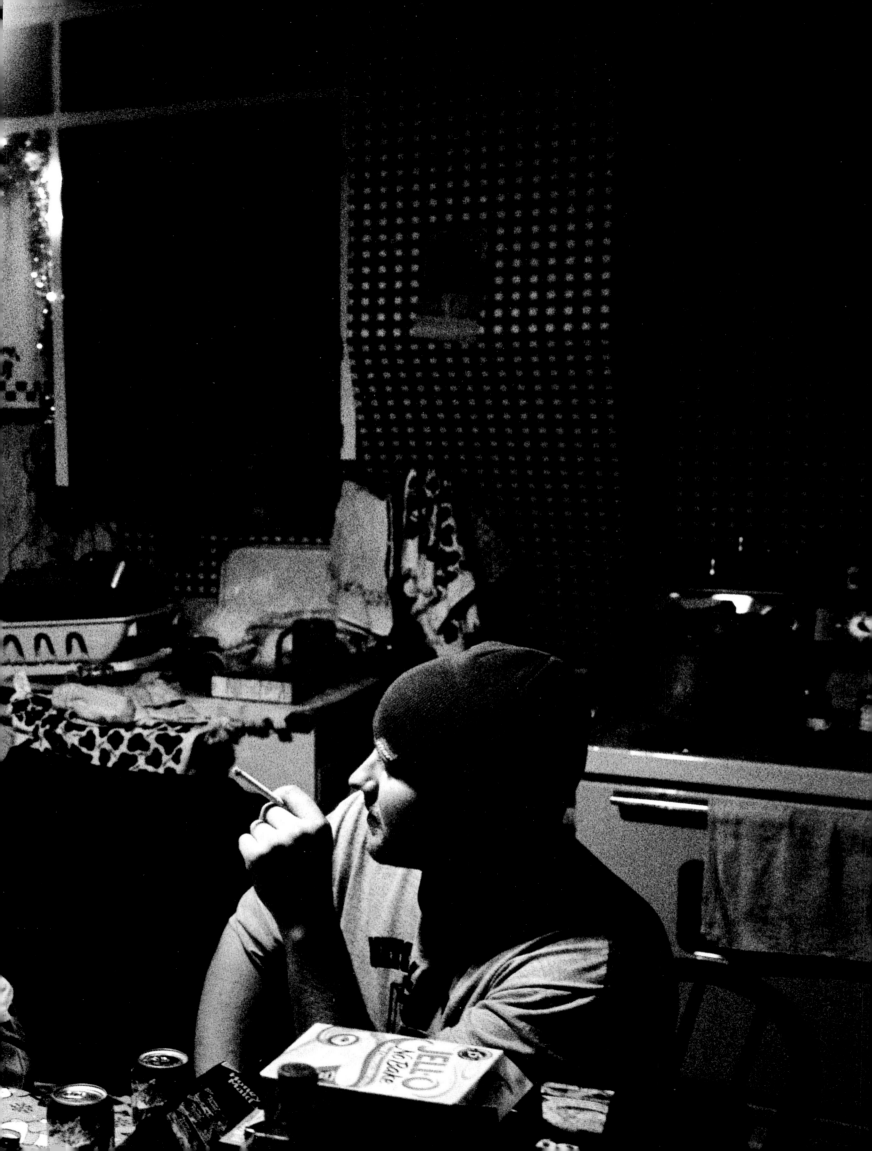

Previous pages: Party at a farmhouse, Johnson County, 2006; *Above:* A man pees, Johnson County, 2004

Opposite: Outside the farmhouse, Johnson County, 2006

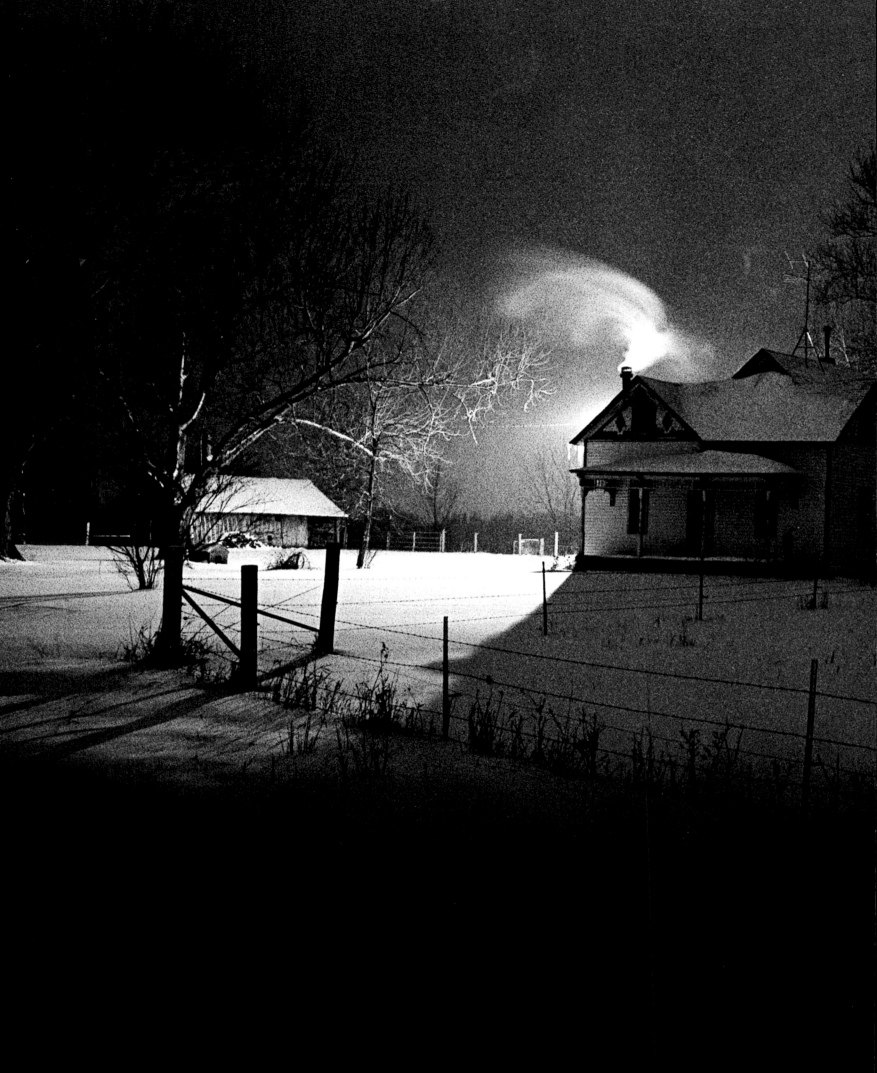

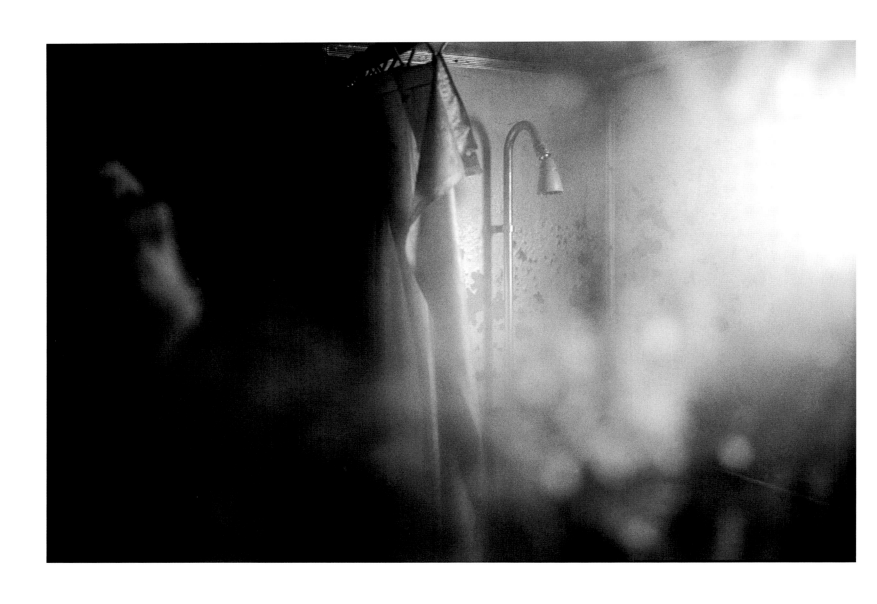

Previous pages: Snow storm, Hills, Iowa, 2004; *Above:* Shower reflected in a mirror at Kenneth Zillmer's trailer in the cornfields, Wellman, 2003

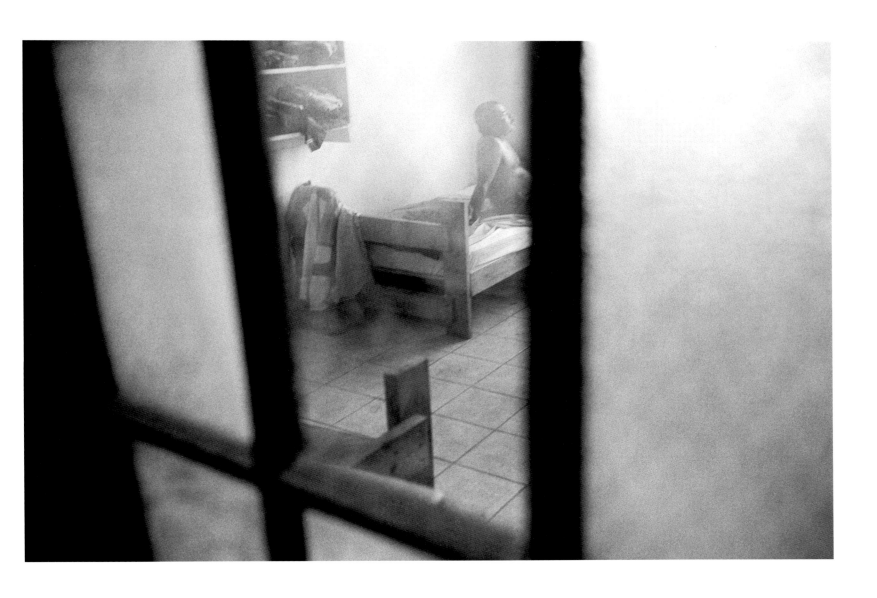

A migrant worker rests after a fourteen-hour day in the fields, Conesville, 2003

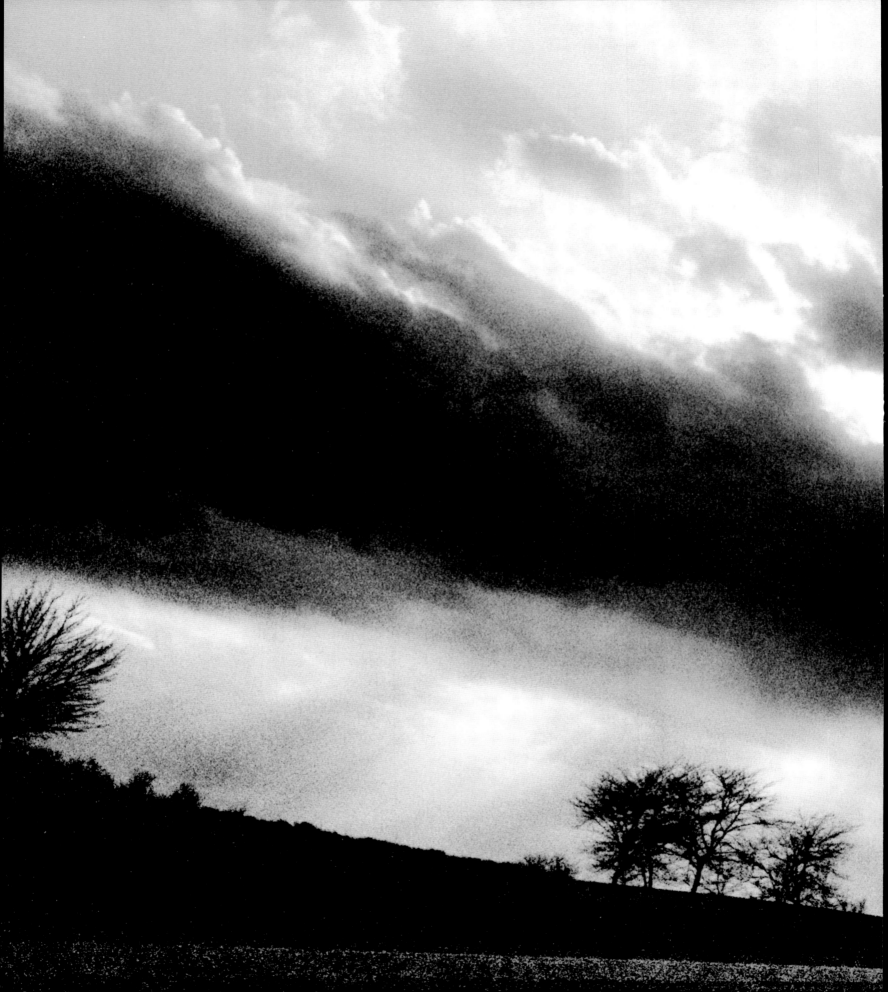

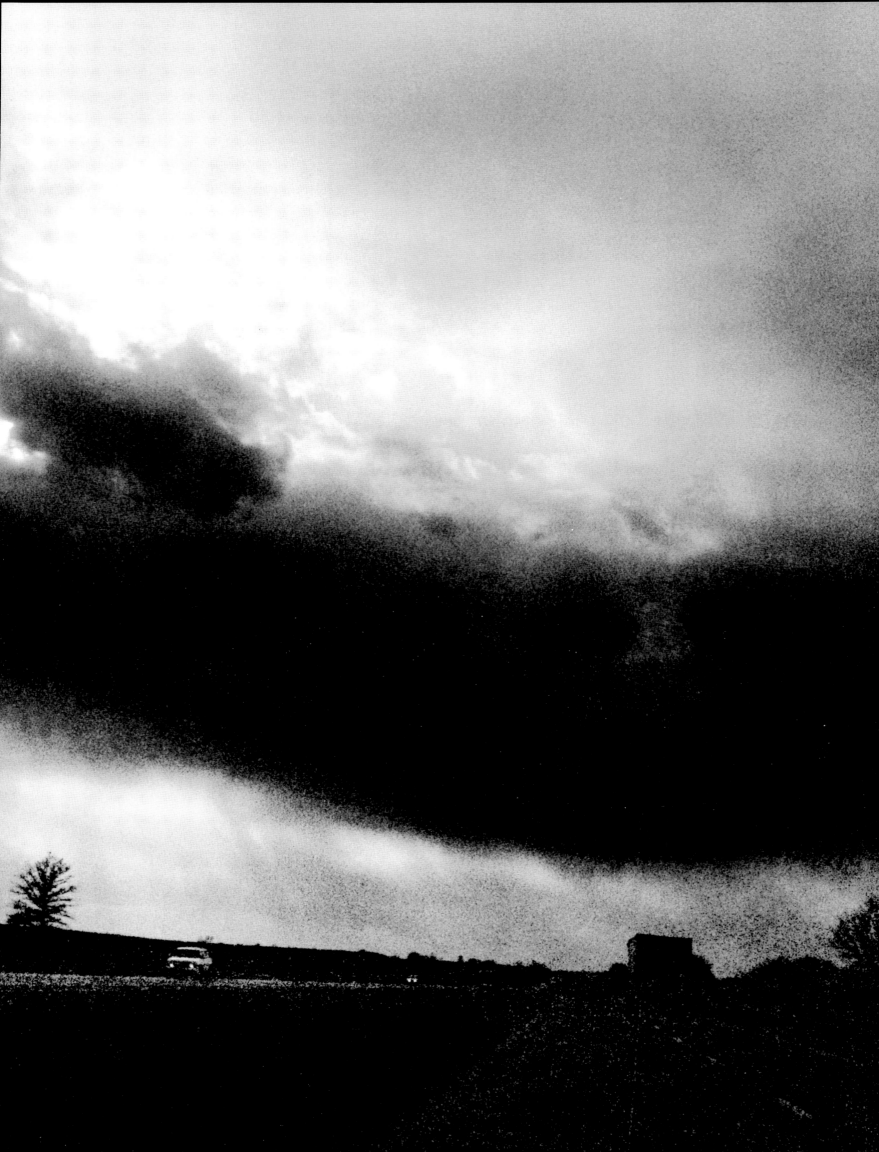